WHEN THE CHISEL HITS THE ROCK

Fred C. Renich

While this book is designed for the reader's personal profit and enjoyment, it is also intended for group study. A Leader's Guide with Victor Multiuse Transparency Masters is available from your local bookstore or from the publisher.

VICTOR BOOKS

a division of SP Publications, Inc.

WHEATON. ILLINOIS 60187

Offices also in Fullerton, California • Whitby, Ontario, Canada • Amersham-on-the-Hill, Bucks, England

photo by Wayne Hanna

Recommended Dewey Decimal Classification: 229.092
 Suggested Subject Headings: Bible—Biography; Apostles.

Library of Congress Catalog Card Number: 80-51394
ISBN: 0-88207-218-8

VICTOR BOOKS
A division of SP Publications, Inc.
P.O. Box 1825 • Wheaton, Illinois 60187

CONTENTS

FOREWORD

In May of 1979, God suddenly called Fred home to Himself. Throughout the 35 years of our marriage, I watched as the Lord fashioned Fred into a leader and changed his ideas about failure and success.

During our years together, Fred and I learned that it is safe to fail. The assurance of this kept us steady and persistent in the work of the Lord. Because of the presence and reality of God in Fred's life, people around the world found that for them too it was safe to fail, because Jesus Christ came to save failures.

Out of the depths of Fred's own personal experience, he wrote with deep insight about God's dealings in Peter's life. In the margin of his Bible beside Psalm 3 Fred had written "God can be trusted, even when we are in trouble that is the result of our own wrongdoing."

For 15 years Fred taught the life and struggles of Simon Peter at Missionary Internship in Farmington, Michigan. This in-depth study proved to be of life-help to scores of people. It was his prayer that God would use this book to help even more men and women to understand God's way in fashioning a person to His design.

Jill Renich
Montrose, Pennsylvania
1980

INTRODUCTION

Years ago when I was still very much a novice in the Christian ministry, I heard Norman Grubb speak of God using *method* as well as *message* in the development of His servants. What Mr. Grubb said at that time lodged as a seed in my mind. During the intervening years, it proved fruitful in my own life and ministry. *Vision. Valley. Fulfillment.* These three terms effectively characterize the three key periods essential to the development of a servant of God. This is God's method. He first imparts *vision* to the person He intends to use. But before fulfillment of that *vision* is possible, He leads His man through the *valley*. It is in the *valley* that God *makes* His man who then becomes the *fulfiller* of his own *vision*.

This book illustrates this method of development as seen in Christ's dealings with Simon Peter. While Peter is by far the most visible of all the disciples as they are portrayed in the four Gospels, I believe the same basic lessons were being learned by the other disciples as well.

As you walk with Simon Peter along his path of spiritual development, may your heart be warmed, your spirit encouraged, and your faith strengthened to trust the Saviour to do for you what He did for His servant so long ago.

Fred Renich
Montrose, Pennsylvania
1979

Vision

1
You Are. . . .
You Shall Be

"You are Simon. . . . You shall be called Cephas."

John. 1:42

Andrew brought his fisherman brother Simon to meet Jesus, the Carpenter from Nazareth. As they approached one another, their eyes met and held. For a long moment Simon felt he was being searched through and through by that piercing yet understanding gaze.

At last Jesus spoke—as a Man, and yet more than a Man. The words were quiet; and like His look, they went to the very depths of Simon's being.

Simon felt that this Stranger knew him intimately. His eyes gripped and His words probed to Simon's innermost soul. And Simon knew he would never be the same again.

"You are Simon the son of John," the Stranger said. "You will become so different that people will call you by another name, Cephas or Peter, a rock."

Two short, simple statements left Simon feeling totally exposed yet amazingly assured. For what he had just heard was the totality of God's message to man.

"You are"—the word of diagnosis.

"You shall be"—the word of promise.

These two statements say everything. Ever since that tragic day

in the Garden of Eden when man said Yes to the tempter, he has been dishonest with himself about who he really is. To be honest would be totally devastating, for he would be faced with the incredible and tragic reality that man is nothing!

Dependent Man

Man was created a dependent being, whose very existence is derived from God, the self-existent One. But the lie man embraced was the assumption that he possessed life in himself and was not really dependent on God. And ever since that horrible moment, man has tried to hide, to cover up, to fool himself into thinking he really *is* someone. The fact is that outside of a vital relationship with God, man's existence is worse than nothing. It is a living death.

Self-Existent God

God can be totally honest. He has nothing to hide and nothing to fear. Being perfectly righteous and completely self-existent, He is within Himself perfect peace and composure. And since He is both the Author *and* the Giver of life—creating and sustaining life outside of Himself—He is not in a panic about man's dilemma. He knows that man *can* live, *can* be someone, *can* be a free person, just as soon as he will freely accept his dependency upon God.

Throughout the Bible and history, God is truthful with man. His first word to your heart and mine is always, "You are." This is the word of diagnosis. Until we accept the truth *about ourselves* as God speaks it to our hearts, we are unable to hear anything else from Him.

Dear God,

Who am I really? What am I truly like? What do You see as You look into the hidden places in my thoughts, motives, desires, and loves? You know how much I want to be independent, and how deeply I fear and resent admitting my total dependence on You. Yet I know I can't guarantee to myself even five minutes of life—much less dictate what shall be beyond the grave.

Forgive my sin of living as though I didn't really need You—for today or forever. Help me to start now being honest with myself and with You about how totally incapable I am in myself, apart from a living relationship of dependence on You.

You have spoken a word of promise. To one like me You have said, "You shall be. . . ."

Lord, I'm not sure what that really means. But it gives me hope. I want to know, for myself, what You have promised to *me*.

Your promise will keep me from despair, for while I don't understand all that it means, I know that it is safe to believe You.

In Jesus' name, Amen.

2
Don't
Be Afraid

But when Simon Peter saw that, he fell down at Jesus' feet, saying: "Depart from me, for I am a sinful man, O Lord!"

Jesus said to Simon, "Do not fear, from now on you will be catching men."

Luke 5:8, 10

They met again, Jesus and Simon, this time at the lakeside after a futile night of fishing. Jesus, surrounded by a milling crowd, borrowed Simon's boat. Pushing out from land He sat in the boat and taught the people. They were hushed and intent as they listened to the Master Teacher. His words were so profound, yet so simple.

After dismissing the crowd, Jesus turned to Simon.

"Put out into the deep water and let down your nets for a catch."

"Master, we worked hard all night and caught nothing, but at Your bidding I will let down the nets" (5:4-5).

The result was a miracle. Fish! Two boats loaded with them! The boats nearly swamped and the nets began to tear.

Intrusion of Light

This intrusion of the miraculous into the routine life of Simon the fisherman made an amazing impact on him. He was gripped by a strange and disturbing awareness that more than mere man was standing beside him. He forgot about the value of fish, and all that two boatloads would mean to hardworking fishermen. Instead, he was caught up in this strange and frightening awareness.

He knew with a subjective knowing how sinful he was. With

that knowledge he became dimly aware of the infinite distance between himself as creature and God as Creator. Light had dawned, though dimly. He suddenly *knew* Jesus was more than man—He was also God.

Gripped by the solemnity of this knowing, Simon couldn't help but cry out to Jesus,

"Depart from me, for I am a sinful man, O Lord."

We must start by believing the truth. That's what Simon did when Jesus first met him with the statement of who Simon was and what he would become. But truth believed must become truth experienced. It's one thing to believe you're a sinner because the Bible says so. It's quite another thing for you to *know through personal awareness* that you *are* a sinner. Believing statements from the Bible can leave you hard and cold. A God given awareness of who you are breaks your heart!

The reason many people are so comfortable in church, reading the Bible, or talking about Christianity, is that they haven't been where Simon was, face to face with who they really are, in contrast to who God really is. Simon couldn't stand it. He wanted to hide, and so he asked God to leave.

Adam and Eve hid from God in the Garden. And that's what every person who hasn't repented of his self-sufficiency will do. There's no way independent man can avoid wishing to hide when he becomes aware of who he is in the presence of God!

Peace with a Promise
Because Jesus was fully aware of what Simon was just beginning to discover, His answer to Simon's panic was positive reassurance.

"Don't be afraid."

That's right. You don't need to be afraid. The One who knew all along what you were also knows what He can cause you to become. It's the word of promise again. Only this time it has a different dimension. The first word of promise related to Simon's character change, from instability to stability. He was volatile, impulsive, and impetuous; he would become stable, dependable, and consistent.

Now, beside two boats full of fish, Jesus didn't refer to Simon's character but rather to his coming vocation.

"Fron now on you will catch men." This was a promise of fruitful service. In effect, Jesus was saying, "You've seen My power to be the key to real success in your daily work; now I will make you successful in serving Me."

"And when they had brought their boats to land, they left everything and followed Him" (Luke 5:11).

Their hearts were attached. Not only Simon's, but James' and John's as well. They left all—and followed!

As they admitted who they were and freely accepted His promise of what they would become, there began a relationship that would deepen until they were known as men of God, servants of the Most High, apostles of the Lamb. This life-surrender of themselves to what little they knew of Him as Lord began the building in their hearts of a dependency-on-God relationship.

This is salvation begun. Along that path alone does salvation become an established life-reality.

"Don't be afraid—*follow Me and I will make you what only I, God, know you can become.*"

Dear Lord,

I've never seen You fill my empty nets after a fruitless night of toil. Nor do I recall ever feeling like Simon and crying, "Depart from me, for I am a sinful man, O Lord!" I know in my heart that it is right for me to live dependent on You. It is wicked to go my independent way.

As best I know how, I turn now from living as though I don't need You. I accept Your command given to Simon, *and to me*, not to be afraid. Like him, I choose to follow You, as You show me how and where. I believe You will make my life fruitful for You, just as You promised to do for Simon so long ago.

Thank You, Lord, for beginning to break the stranglehold that material things, like boatloads of fish, have had on me. I want to let go of them to follow You.

In Jesus' name, Amen.

3
Faith Has Legs— It Obeys

"Lord, if it is You, command me to come to You on the water."
And He said, "Come!"

Matthew 14:28-29

After Jesus had miraculously fed 5,000 men, plus women and children, the crowd wanted to make Him their king. Jesus told His disciples to go by boat across the Sea of Galilee, while He remained behind to disperse the crowd. Later, as night began to fall, He went up into the nearby hills to be alone for prayer.

A violent storm had come up on the sea, turning the disciples' trip into a battle for survival. Seasoned fishermen though they were, they made little headway against the howling wind and surging waves.

Suddenly, in the predawn darkness, the disciples saw an apparition coming toward them, walking *on* the water. Believing it was a ghost, they shrieked in fear! To their astonishment a voice came clearly above the noise of the storm.

"Don't be afraid. It is I."

In an instant of impulse, Simon Peter shouted back, "Lord, if it is *You,* command me to come to You *on* the water."

"Come."

Astonishment
What would *you* have done? People *don't walk* on water.

17

But Simon climbed over the side of the boat and—*started walking on the water* to go to Jesus.

The disciples must have been frozen in incredulity as they watched the drama unfold. Simon was doing the totally impossible. For a few fascinating moments they forgot about the storm, their eyes riveted on that incredible scene. One of their own group was demonstrating a fundamental principle that they were all to learn in the months and years ahead: Faith in Jesus Christ is expressed by obedience to His commands, even when those commands call a person to perform the impossible. For with His commands, Jesus Christ gives the power to obey them.

The Bible speaks repeatedly of the "obedience of faith," doing what God requires with a trusting heart. There is all the difference in the world between obedience that springs from an attitude of trust, and forced conformity that is based on fear and unbelief. This conformity is what the Bible calls "dead works" (Heb. 9:14). Trying to obey a God whom you don't trust, and therefore don't love, is like a reluctant son going through the motions of pleasing a father whom he dreads. His heart is not in it, and as soon as he is out from under his father's pressure, he will turn to things that please himself.

Confidence

The all-important matter to a person rightly related to God is not, "*Can* I do it?" but rather, "*What* has He told me to do?" Having his directions clear, he steps out in the confidence that *he can do* what God has commanded him to do.

Unbelief says, "Of course, I can't obey God," or "God is a hard Master to demand of me what I cannot perform."

Faith says, "I can obey God."

Unbelief dishonors God by its reluctant, halfhearted, and unbelieving performance. Faith honors God by obedience.

Dear Lord,

Forgive me for the many times I've said to myself that I couldn't obey You because You were a hard Master. You have promised

that Your commandments are not too difficult, and are not grievous.

Make me sensitive to commandments I have ignored or refused, and courageous in doing Your will. When I face circumstances that demand the seemingly impossible, enable me to choose what is right, and to trust You with the results of my actions.

In Jesus' name, Amen.

4
It Is Safe to Fail

But seeing the wind, he became afraid, and beginning to sink, he cried out, saying, "Lord, save me!" And immediately Jesus stretched out His hand and took hold of him and said to him, "O you of little faith, why did you doubt?"

Matthew 14:30-31

We can only speculate on what prompted Peter's amazing request, "Lord, if it is You, command me to come to You on the water." Carried along by the enthusiasm of his own impulsive request, he followed through by daring to step out of the safety of the boat onto the turbulent sea.

All went well for a few thrilling moments. We can imagine the feeling of buoyancy that must have filled Simon. In his daring abandonment, he found himself actually doing what Jesus had commanded him to do.

Then suddenly, disaster! A huge wave . . . a picture of the absurdity and impossibility of it all . . . and a bold disciple floundered and began to sink. In desperation he cried, "Lord, save me."

Immediately—without reproach or condemnation—Jesus reached out, lifting Simon to his feet on the water. As they walked to the boat together, Jesus' only comment was one of mild reproof and encouragement:

"O you of little faith, why did you doubt?" (v. 31)

It Is Safe to Fail

In those moments in the wild sea, Simon Peter learned two critical lessons which every one of us needs to learn. As he stepped out of the boat, he discovered it *is* possible to obey commands that require the humanly impossible. Now he learned an equally important lesson—*it is safe to fail!*

However, this lesson cannot be learned without actually failing. The failure often comes in a situation in which we haven't given a single thought to the possibility of failing. And it often comes also in a moment when our faith seems invincible. We are being carried along by a thrilling abandonment of trust, doing what we are sure God has told us to do, when suddenly—all goes wrong!

Pages could be written describing how Simon *might* have reacted in his moment of crisis. But all we *need* to know has been told us—he cried out to the Lord. As Simon accepted his helplessness in the very act of failing, he turned to Jesus Christ with the cry of a helpless child, "Lord, save me!"

It Is Safe to Bank on God

Immediately Jesus took over. All the power of Omnipotence reached out to lift a panic-filled, floundering disciple. Simon Peter discovered in that moment that the weakness of a person's trust does *not* alter the love and care of God, nor limit His redeeming power.

It is safe to fail only because it is totally safe to bank unreservedly on a God who loves you with a deep, personal, caring kind of love.

Have you ever spent time whipping yourself for failure? Had some of us been Simon, we would have thought:

• "I blew it because I didn't pray about it before acting so rashly."

• "Could it be that my problem was a secret desire to do the spectacular? At the root of that is pride, and I should have remembered that pride goes before a fall."

• "You know, I didn't share my idea with my Christian friends. After all, I should have checked it out with the other disciples."

- "Why didn't I try harder to keep on walking?"
- "I was a bit presumptuous to think *I* could do the miraculous."
- "I guess God wanted to make me more humble. If I had succeeded, maybe I'd have become puffed up."

It Is Safe to Obey

Our tragedy is that we often spend time, energy, and spiritual reserves rehashing all the seemingly rational reasons for failure, instead of sticking to a few central issues:

- It *is* safe to launch out in obedience to God's commands, even when He has asked us to do the impossible.
- Obedience is possible as long as we keep our eyes on Him and act in full confidence that we *can* do what He has commanded us to do.
- The obedience that flows from a trusting heart is often tested. In Simon's case, the sea did not become calm so it would be easier to walk on the water. When God told His people to follow Him from Egypt to a land flowing with milk and honey, He led them through a desert. There was no water there, nor food, nor shelter from the scorching sun. Again and again the obstacles in their way revealed the weakness of their trust.
- The root cause of failure is the immaturity of our trust, not lack of personal dedication, weakness of effort, or 101 other plausible reasons.
- When we do fail, the answer is usually found in honestly accepting our plight, and in trustingly calling God to rescue us.

It Is Safe to Wait for God

What should be your course of action following a failure? Do whatever God tells you. And what He commands may have no relationship to the incident in which you failed. There are those who would insist on trying over again to walk alone on the water—as though they must prove a point. But Simon Peter didn't try, and Jesus didn't ask.

When you fail, get up and say to God, "OK, Lord. Now what?"

The important thing is not whether you succeed or fail, but rather, if you respond to His directives with action that is rooted in trust.

When I was a student in college, I went through a period when I was sure God was telling me to resign my job and trust Him alone for the supply of my daily needs. But nothing worked, and I was thoroughly confused. Bills piled up and eventually I went back to work. As far as I could tell, I had failed to trust. But I left it with the Lord; and although there were struggles, God kept me free from self-condemnation.

Several years later I was faced again with the conviction that I should step out on faith, trusting God for all my needs, making them known to Him alone. This time it worked. For several years I lived that way, including a period when my wife and I were missionaries overseas. Later God changed His directives and we returned to working for a salary.

Don't be afraid of failure. It can't hurt you if you let God take over.

Dear heavenly Father,

How often I've beaten myself for my failures. And even worse, I've been unwilling to make it safe for those around me to fail.

Thank You that there *is* freedom from the pressures of our success-oriented society. Please keep reminding me that my one job is to obey Your commands, knowing that with each command You give the ability to carry it out.

And, Lord, when like Simon Peter I panic because of the turbulent circumstances, give me grace to admit my failure and to trust You to save me from the results of my own faltering faith.

In Jesus' name, Amen.

5
Leave You?
For Whom?

Many of His disciples withdrew, and were not walking with Him any more. Jesus said therefore to the Twelve, "You do not want to go away also, do you?" Simon Peter answered Him, "Lord, to whom shall we go? You have words of eternal life."

John 6:66-68

The crowd was insistent. They would not be denied. Jesus was the king they wanted, and since He wouldn't proclaim Himself, they would make Him king. What had begun as an insignificant handful of followers had become a popular movement.

This Man could do *anything*. The people knew this because of His miraculous provision for them. With a word He had multiplied a boy's simple lunch into more than enough food to satisfy thousands of hungry people.

In spite of their clamor He had quietly refused to become their king and had insisted that they return to their homes. His commands had such power that they felt compelled to retreat.

That was yesterday. As this morning dawned the surge of excitement revived and the crowds went in search of Jesus, to make Him their king.

Seeking a King

They found Him across the lake. But as they began to press Him with their desire, He rebuffed them. He seemed to care nothing for

their enthusiasm and professed loyalty. Most men would have grabbed the chance to ride to power on the crest of popular acclaim. But Jesus threw disturbing challenges at them:

"I know why you came all the way across the lake to look for Me. It was not because you saw the evidence of God in Me. You sought Me only because I miraculously gave you a free meal. You want Me only for the things you need in this life.

"I came for a different reason and I have a different kind of food for those of you who are really hungry. The bread I give is food for your souls. Physical food satisfies only for the moment. Even the miracle manna that Moses gave your forefathers left them hungry the next day. Your main needs are not physical, for the body is earthly, temporary. Physical life has an end. This world is but for a moment.

"My kingdom is eternal and represents another order than this world. I will be king only of those who in their hearts love that unseen, righteous, and eternal kingdom.

"The way into that kingdom is through a heart relationship to Me, and to everything I stand for. The relationship with Me must be so close it will be like eating My flesh and drinking My blood. For My life to become your life, you must renounce your allegiance to this world, your devotion to its values, and your enslavement to its ways.

"The way into My kingdom is so difficult that only those whose hearts are moved by My heavenly Father can find it. If you only knew, you would despair of entering My kingdom unless God would give you a complete change of heart."

His speech cut them to the heart. Some became angry and others were puzzled. What strange and foolish talking—was the Man mad? What did He mean, "Eat His flesh and drink His blood"? Did He want them to become cannibals?

But most offensive of all was His implication that He would be their king on His terms alone—*not on theirs!*

They had had enough authority imposed from above. The right to govern must arise from the consent of the governed. And they wanted a king who would give them freedom now—a freedom

from oppression, fear of hunger, and the bondage of sickness, disaster, and disease.

"Go, take Your heavenly kingdom! You aren't the Messiah we thought You were. We'll look and hope and wait for someone who cares for our loyalty and who can meet our terms."

Confessing His King

Almost everyone left. The clamor ceased, and the scene grew strangely silent. The wind whispered through the branches of the olive trees. Jesus stood silent, watching as the last of the retreating throng disappeared over the brow of the hill. Then He turned to a handful of men nearby. His voice was low—but not despairing. A strange look of triumph mingled with sadness filled His face. In the impenetrable mystery of that moment He spoke as a king:

"Are you going to leave Me too?"

Simon Peter answered, "Lord, who else is there to go to? You alone have that which leads to eternal life. And we believe *You!* There's no one else to turn to."

There is a sifting that must take place in every heart. Jesus will be followed for *who He is,* not because the crowd is going His way.

There *is* a Christian crowd, made up of those who for a variety of reasons want to be a part of the current "in group." This is true at all levels of society, in any age, or in any culture. Few people are comfortable standing alone for it is difficult to move against the current.

In many groups, a person is not really "in" unless he describes his conversion by certain words, like, "I accepted Jesus Christ as my Saviour" or "I was born again." Some even have to be able to state the time and place where it happened. In other groups it is important to agree with the teachings of those who are considered "acceptable" teachers or leaders at the moment.

But every profession of relationship will be tested. Jesus Christ will be loved, trusted, and served for His own sake—just because He is God. True relationship is intensely personal. In the stability of the kingdom of God, each member is to be so personally related to the King that he will remain true, regardless of what others do.

You may know whether your relationship to Jesus Christ is genuine by asking yourself if you can say with Simon Peter,

"Lord, only You have the truth that leads to eternal life. There is none other to go to."

Dear heavenly Father,

Do I love You, trust and follow You for who You are, or mostly for the beautiful things You promise to give? Am I just part of the "Christian crowd," interested in popular acceptance for the moment?

Thank You for sifting and testing my heart. Thank You for not letting me get by with mere lip-service to You. Lord, You brought Simon Peter to the place where he *knew* that You alone had the answers to his heart need. I trust You to do the same for me.

Thank You for the deepening awareness that You are my king. Thank You that my love for Your eternal kingdom is growing. Thank You for Your faithfulness to create in me an ever stronger heart attachment to that kingdom which is unseen but eternal, and a growing freedom from the lure and enslavement of this temporal world.

In Jesus' name, Amen.

6
Didn't I
Choose You?

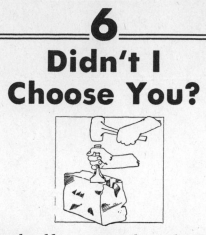

"We have believed and have come to know that You are the Holy One of God." Jesus answered them, "Did I Myself not choose you, the Twelve, and yet one of you is a devil?"

John 6:69-70

Jesus' disturbing question, "Will you also go away?" shook the little band of disciples. Yes, the crowd had deserted Him, but didn't Jesus know *they* were loyal? Did He have doubts about *them?*

Simon Peter assumed he spoke for them all—"*We* have believed—and *we know*."

"Do you?" replied Jesus. "Don't be too sure. I see what you can't see, and know what you have no way of knowing. Yes, I chose each of you, but one of you is a devil—my archenemy, in league with this world and its prince."

The doctrine of assurance is comforting *and* dangerous! It can easily become presumption. This is especially true at a time when it is unpopular to question the certainty of one's relationship to Christ. Because some people talk freely about a know-so salvation, you may have been challenged by someone's bold statements:

"You mean you aren't *sure* of heaven? That's too bad. I know I sin a lot, but that doesn't overly disturb me. The Bible says that if we confess our sins, Jesus is faithful to forgive us our sins and

cleanse us from all unrighteousness. I've done that and on the basis of His Word, I *know!* The way I live doesn't have anything to do with my being a Christian, as long as I confess whenever I sin. What *you* need is assurance of your salvation. I'm sure glad I don't have to go through life wondering if I'll make it in the end!''

Jesus did not express doubt about the validity of Simon's faith, but He did challenge his right to speak for the group. Furthermore, Jesus did not identify which of the disciples was the traitor. Since each of them appeared equally dedicated, His statement implied a warning.

"Don't be overconfident, Simon. Speak only for yourself, and even then make sure you read your heart correctly.''

Assurance Based on Realities

Only God really knows your heart. "The heart is more deceitful than all else and is desperately sick; who can understand it?'' (Jer. 17:9)

Does this mean you should not be confident about your relationship to Jesus Christ? That you should be hesitant, doubting, and timid? No indeed! But let your assurance be solidly based on the realities of man's heart and God's holiness.

True faith is always honest, and does not shut its eyes to reality. We must become increasingly aware of our ever present tendency to use the mercy of a loving God, and His readiness to forgive, as an excuse for careless living.

Haven't you ever been secretly glad for ideas like the following:

• Don't worry, God won't really mind if you indulge yourself. Since Christ has already paid the penalty for your sins, they are taken care of, even before you commit them.

• Don't you know the Christian will *never* be judged for his sins? Christ took care of that on the cross.

• When you accepted Christ, your entrance into heaven was made absolutely certain. At the most, careless living will deprive you of some heavenly rewards. Of course, you will also miss the blessings of fellowship with Christ now. But that can be easily restored if you will confess your sins as soon as you commit them.

But don't let anyone ever persuade you that you weren't eternally secure the moment you accepted Christ.

• Remember, works have *nothing* to do with getting to heaven. You are saved by grace and grace alone. Works have to do only with rewards!

Those who teach such ideas use many proof texts for support. And the pressures generated by these insistent teachers, along with the attitudes of the many who follow them, make it extremely difficult for people to reach solid conclusions about what the Bible *really* teaches.

Assurance and Godly Fear

Yes, there *is* assurance for the believing soul. But there can *never* be an assurance that encourages careless living. It is God Himself who gives true assurance, and He gives it only to those whose hearts are right with Him.

Such a person has the child-spirit attitude (Matt. 18:3-4). He is "poor in spirit" (Matt. 5:3), with a "contrite and lowly" spirit (Isa. 57:15). He is "humble and contrite of spirit," and trembles at God's Word (Isa. 66:2). Being one of Christ's sheep, he hears the Shepherd's voice and follows (John 10:27). He knows the fear of the Lord which is the beginning of wisdom (Prov. 9:10). And at the root of his relationship to Jesus Christ is a Spirit-wrought godly fear, which arises from the awareness that the God he serves is a consuming fire (Heb. 5:7; 12:28-29).

Such a person finds himself restrained from brash, self-confident statements about his relationship to Christ and the certainty of his future. The issues are far too solemn, and there are too many unknowns and imponderables. So he thanks God for His mercy and for the complete sufficiency of Christ's sacrifice on the cross. He believes God's promises and comes boldly to the throne of grace to receive their fulfillment. But he can never escape the fact that even the Apostle Paul lived his life with a dual motivation: "Knowing the fear of the Lord . . . the love of Christ controls us" (2 Cor. 5:11, 14).

He remembers the command of the psalmist: "Serve the Lord

with fear, and rejoice with trembling'' (Ps. 2:11, NIV). And each succeeding day he seeks to work out his "salvation with fear and trembling; for it is God who is at work . . . both to will and to work for His good pleasure" (Phil. 2:12-13).

Make it your goal always to be perfectly secure in Christ, but totally insecure in sin!

Dear Father in heaven,

I confess how little I am aware of the solemnity of the issues involved in being rightly related to You, a holy God. I thank You for the assurance that I don't need to live in the torture of uncertainty about Your love. But my heart is tricky, and the pressures to live carelessly and self-indulgently are real and ever present.

Lord, forgive me for presuming on Your mercy, and plunging on boldly and brashly in my own way. Revive in my heart—and in the church—God-given fear of You, for this is the real beginning of wisdom, the foundation of true godly living, and the basis of genuine assurance.

In Jesus' name, Amen.

7
Taught by God

Simon Peter answered and said, "Thou art the Christ, the Son of the living God." And Jesus answered and said unto him, "Blessed are you, Simon Barjonas: because flesh and blood did not reveal this to you, but My Father who is in heaven."

Matthew 16:16-17

The air was full of excitement. Rumors were flying. People would gather in little groups at village wells, in marketplaces, or at busy intersections in the larger towns. Inevitably the conversation turned to the burning question: "Who *is* Jesus of Nazareth?"

Every day brought new reports of Jesus' miracles, feeding flames of popular support for Him. At the same time there were increasing expressions of disapproval by those in positions of religious, political, and social leadership. His staunchest supporter, John the Baptist, had been imprisoned and then executed.

As though sensing the gathering storm, Jesus withdrew from the crowds and retreated with His disciples to the sparsely settled foothills of Mt. Hermon in the northern part of the country. There, alone with the Twelve, He began to question them.

"What are people saying about Me? Who do they say I am?"

Their answers revealed the extent of bewilderment among the people. No one seemed to agree about who He was.

Suddenly Jesus shifted His question. With burning intensity, He focused on the disciples whom He had personally chosen.

"Who do *you* say I am?" He asked.

Without hesitation, in a voice clear and certain, Simon Peter replied, "You are the Christ, the Son of the living God."

The moment was electric. Not a whisper disturbed the awesome intensity that had suddenly developed within that little group . Did Simon know what he had really said? If it were true, then the crossroads of history had been reached; the hour of destiny had struck. Everything written in the ancient law and prophets, that for which the faithful of all ages had yearned, waited, and prayed, was on the verge of fulfillment.

Jesus broke the stillness. His words were solemn yet exultant: "Blessed are you, Simon Barjonas, because flesh and blood did not reveal this to you, but My Father who is in heaven."

The Great Divide
There is a world of difference between an intellectual assent to the deity of Jesus Christ and a God-given heart awareness of His divinity. That difference is measured by the infinite distance between the enlightened but lost soul and the redeemed and reborn individual. It is the distance between hell and heaven, between exclusion to the outer darkness, where there is the weeping and gnashing of teeth and membership in the eternal kingdom of our Lord Jesus Christ.

Are we not to believe intellectually that Jesus Christ is divine? Certainly. And millions affirm that belief by reciting the Apostles' Creed in their worship.

The tragedy is that so many stop there. Theological investigation, study, and the weighing of evidence and arguments are all good in themselves, but they are *not enough*.

All searching for truth must lead to this heart of the whole matter—that which Simon Peter had experienced—the miracle of the divine unveiling.

The Divine Action
Salvation is God's act, not man's action! While there are steps we must take, unless God acts for each of us personally, intimately,

and in His own time and way, we remain strangers, outsiders. The Bible makes clear what salvation is—the living God making Himself known *personally* to an individual.

"God . . . has shone in our hearts to give the light of the knowledge of the glory of God in the face of Jesus Christ" (2 Cor. 4:6).

"And this is eternal life, that they may know Thee the only true God, and Jesus Christ whom Thou hast sent" (John 17:3).

"No one knows the Son, except the Father; nor does anyone know the Father, except the Son, and anyone to whom the Son wills to reveal Him" (Matt. 11:27).

Here is the fulfillment of that mysterious yet glorious promise in Isaiah 54:13, "And all your sons will be taught of the Lord." Jesus referred to that promise in His amazing statement in John 6:45-47, "It is written in the prophets, 'And they shall all be taught of God.' Every one who has heard and learned from the Father, comes to Me. Not that any man has seen the Father, except the One who is from God; He has seen the Father. Truly, truly, I say to you, he who believes has eternal life." This was spoken to puzzled Jews, many of whom were zealously committed to worshiping and serving God.

Between man and God is an impenetrable curtain of unknowing. Only God can draw that curtain aside and grant to man a certain, sure, unshakable "knowing" of who Jesus Christ is. When that "knowing" is given, when the light dawns, when the curtain is drawn aside, then, and only then, does the heart *know* who Jesus Christ is.

Only then does Christ become *God* to the soul. Only then does the heart bow and say, like Thomas, "My Lord and my God!" (John 20:28)

Everything Jesus had said and done up to this moment, beginning with His first meeting with Simon Peter, was calculated to bring this "knowing" to pass.

For Simon Peter a new day had dawned. For Jesus Christ a great victory had been achieved—the darkness of a human spirit had been flooded with light!

The Saving Process

The overemphasis today on the act of "receiving Christ" as one's Saviour has obscured the broader truth that salvation is also a process. The failure to make this clear has done immeasurable harm to countless numbers who, having "received Christ," have failed to follow on to really *know* the Lord. Being assured that the one act of "receiving Christ" made them safe for eternity, they rested in that step and in time turned back in their heart's attitude and later in their actions to the world from which they were supposed to have been saved.

Although Simon's great confession of God's work in Him was the culmination of a process which involved all of his preceding experiences, *no single one or all of those experiences together would have been sufficient in themselves to establish Simon Peter as a Christian.*

Only as the "light of heaven" dawns upon the soul, revealing to it that Jesus Christ is God, is the soul brought to a full-orbed birth from above. To the degree that you *know* Jesus Christ as God—to that degree you are settled as a Christian. But this knowledge must be profoundly more than a belief of Scripture texts. It includes belief of Scripture, but goes beyond it. It is nothing less than God making known to you who Jesus Christ is.

For your soul's sake, don't stop short of that awareness. Here is the real meaning of the truth, " 'You will seek Me and find Me, when you search for Me with all your heart. And I will be found by you,' saith the Lord" (Jer. 29:13-14).

You may wonder, *Am I to sit passively waiting for this work of God in my heart? Or am I to agonize in prayer until a light "dawns" within?*

Neither. God gives more light to those who respond to the light they already have. Simon Peter demonstrated this principle in his responses to Jesus Christ and His Word, prior to the great confession.

You can begin right where you are to read and study the Bible in an honest effort to learn the truth. You can also do whatever you believe is right in your present situation. For it takes a personal

commitment to obey what you understand the Bible teaches. It involves a surrender of your will to Christ as your Lord, even though you don't know much about Him. This surrender must be your personal trust that God will do in you and for you *all* you need for Him to do.

Dear heavenly Father,

Please show me if I have settled down in a passive mental acceptance of what the Bible says about Christ. I see more clearly the sin of settling for anything less than a growing, God-given awareness of who Christ is. Right now I claim for myself and for the church that promise, "They shall all be taught of God."

Create in me and in Christians everywhere a growing hunger for such an awareness of Christ, so that the world outside may see a new expression in us of a living relationship to Him, our unseen but almighty and very real Saviour and Lord.

In Jesus' name, Amen.

8
You Are
a Rock

"I say to you that you are Peter" [petros, a stone].
Matthew 16:18

When Jesus and Simon met the first time, Jesus gave him that great promise,
"You shall be called . . . a rock!"
Now He told him, "You *are* a rock." The promise was fulfilled. The great change had come.

But Simon Peter still was anything but a stable person. His character was unpredictable, and in the near future his vehement declarations of loyalty would be followed by panic-filled and self-serving denial.

But the promise, as Jesus had given it, implied a change in Simon's character. "You *shall be called* a rock," is the way Jesus had stated it, meaning Simon would become so different that men would give him a name appropriate to what they would observe in his life—stability, dependability, strength, and consistency.

What then did Jesus mean, "You are a rock"? Lasting and beneficial change in personal behavior does not occur without a valid reason. Good habits can be built upon the sand. All can seem genuine until the storms of adversity sweep over the soul. But when the foundation of a person's character is secure, whatever is built upon it will stand.

The foundation Simon needed became his when he "knew" by

heaven-sent awareness that Jesus Christ is God. From that point on he could never be the same. Nor can any man. For when he *knows* in his heart who Jesus is, and acknowledges it as Simon did, life becomes totally different. Such a man is anchored in the truth expressed by statements such as these:

The fear of the Lord is the beginning of wisdom, and the knowledge of the Holy One is understanding (Prov. 9:10). Thus says the Lord, "Let not a wise man boast of his wisdom, and let not the mighty man boast of his might, let not a rich man boast of his riches; but let him who boasts boast of this, that he understands and knows Me, that I am the Lord who exercises lovingkindness, justice, and righteousness on earth; for I delight in these things," declares the Lord (Jer. 9:23-24).

What Do You Worship?

Inevitably we become like that which we worship. Our behavior—our total lifestyle—reflects our highest allegiance and our hearts' homage. Only when Jesus Christ becomes *God* to us is our foundation adequate for the development of behavior which is appropriate for both time and eternity. Jesus Christ demonstrated the only life pattern acceptable to a holy God. He showed this by His earthly behavior and by His relationship to His Father.

As Jesus Christ becomes God to me, I gain a fixed point of reference for living. I also gain sufficient motivation to assure ongoing and positive behavior changes.

Therefore we need *first* to examine our spiritual foundations. Many who are concerned about wrong practices never ask the deeper question, "Just *who* is Jesus Christ to me?"

The question is not, "Do you believe what the Bible says about Him?" It is rather, "Do you *know* Him? Is He God to you?"

Each person needs this spiritual reality as his anchor, his sure refuge, and the rock upon which he builds his life.

It is tragic that so many people believe that right doctrine will inevitably result in right practice. They give much attention to "teaching Bible content" as the sure guarantee for right living.

Their error lies not in teaching the Bible, *but in stopping there*.

Knowledge of the Scriptures, without the *heart* being taken captive by the Lord of the Scriptures, is deadly. Such knowledge puffs up the mind and leaves the heart cold and hard, and a stranger to the impelling dynamics of a living relationship.

What Motivates You?

Contrary to popular opinion, knowledge does not in itself motivate people to acceptable behavior. *People are motivated by what they love, not by what they know*. It is well known that smoking and cancer are related. Does that stop most smokers? Overeating and heart problems are also related. Yet millions of Americans continue to overeat. In the realm of the spirit it is no different—people follow their hearts, not their heads.

"Where your treasure is, there will your heart be also" (Matt. 6:21). And where your heart is, your actions will also be. Sooner or later you will follow what you love, and do what you really want to do. You may believe what you like about Jesus; but unless He becomes your heart treasure, you will forsake Him when the real crisis comes. You will follow whatever your heart is really attached to.

Up to now most of Simon's experiences were very positive in nature. They were calculated to win, to encourage, to bring Simon to this crucial point of God-given "knowing." But the Holy Spirit's great objective in Simon was to bring him to the place where he was inexorably drawn by the powerful and amazing dynamic of a living bond between his soul and God.

This bonding takes place as God kindles in man's heart that hunger and thirst of soul which relentlessly drove the patriarchs of old, in their lifelong search for the reality that was not of this world. (See Heb. 11:8-16.) To see this bond reestablished between fallen man and God is nothing less than a miracle. And it is of such magnitude that the creation of worlds is nothing in comparison.

Because many present-day concepts of salvation are pathetically superficial and inadequate, it is no wonder that people fall away.

Like Israel of old, "Their deeds will not allow them to return to their God. For a spirit of harlotry is within them, and they know not the Lord" (Hosea 5:4).

For Peter, the real life-changing work of redemption could now begin. God does His deep changing of life patterns in those who are truly His. Jesus came to "save His people from their sins" (Matt. 1:21). We must be irrevocably His before we may expect deep inward changes to be wrought in our lives.

Many have sung the following lines, and have meant the words as far as they understood them. But a glorious change takes place, when the Lord Himself unveils to the heart the reality of which the hymn speaks:

Oh soul, do you know Him?
Know Him?
Know Him?
Oh soul, do you *know* Him?
Jesus Christ the Lord.

Dear heavenly Father,

I thank You that the godly character You require grows in a living relationship to Jesus Christ, the Lord. I confess how often I have struggled with improper behavior, giving little or no attention to whether Jesus Christ was God to me.

Forgive me for trying to build my house of right living on the shifting sands of my own self-effort.

I anticipate with joy Christ's triumphant dealings in my life that shall result in my becoming well pleasing in my relationship to You and in my daily behavior.

In Jesus' name, Amen.

9
God
Will Build

"Upon this rock [petra, bedrock], I will build My church; and the gates of hades shall not overpower it."

Matthew 16:18

Jesus said He would build His church! It would be built on a foundation.

That which He built would be impregnable, unassailable, able to stand against all the onslaughts of death and hell. It would be triumphant, enduring, eternal.

Running through the Bible like a golden thread is a flowing stream of glorious promises. They give us glimpses of God's purposes, which are so mighty and far-reaching that they are incomprehensible to unaided human reason. The fulfillment of these purposes begins in time but culminates in eternity. Earth is thus linked with heaven, the tangible with the intangible, the temporal with the eternal. What an amazing mystery that sinful man, a creature of dust and a prisoner of time, is destined to be involved in God's plans for the endless ages.

The meaning of those promises is apprehended only by those who have been brought into a God-wrought relationship with Jesus Christ as God. Jesus gave Peter the first glimpse of that which He purposed to do. And central to what He said was that unconditional and positive declaration of the One who would be doing it. He said, *"I will build."*

Secure Promises

All the promises of God are positive. God never says He will try to do this or that. There is a beautiful finality about what He has spoken. When Jesus and Peter first met, He declared that Simon *would* be called a rock! Simon's character *would* be transformed.

Again, beside the Sea of Galilee, after a miracle catch of fish, Jesus declared to the bewildered Simon, "I *will* make you a fisher of men." Simon's life would become fruitful in a divinely developed vocation.

And now He spoke the third promise: "I *will* build My church, and it shall be built on the same heaven-wrought foundation that has been worked in you, Peter. That which has made you a rock is that which shall stand as the foundation of the eternal kingdom of God."

God Will Do His Work

Any person who has been truly effective in his life, witness, and work for God, has first been brought to a deep, settled, Spirit-given consciousness that *God will do His work*. This awareness provides the basis for rest in the midst of toil, encouragement when all seems to go wrong, peace when unrest and pressure jostle on every side. It preserves him from the threat of his own humanity; and as his goals are reached, it enables him to ascribe all the credit and glory to God alone.

"I will build My church." Jesus' use of the word *church* may have been new, but what He meant by it was not new. God's purpose has always been the restoration of a living, intimate, enduring relationship between God and man. Throughout the Old Testament, God always referred to the redeemed man as being totally and permanently reconciled to God. The term *church* is but another way of expressing "my people," or "the kingdom," or the "sons of the living God."

The Hebrew people had conceived of redemption in physical terms: deliverance from enemies, removal of the earth's curse, establishment of a lasting kingdom with a king ruling in splendor over a powerful Jewish nation.

Kingdom Relationships

But all the glory and splendor expressed in Old Testament passages descriptive of a coming kingdom are totally impossible unless man has a right relationship to God.

What would heaven be like if human unbelief and rebellion were lurking under the surface? The essence of heaven is the total oneness of man's heart beating with God's heart. Take away this *relationship* and heaven ceases to be!

In effect Jesus was saying, "I have come to do in others what has happened to you, Simon. This miracle work in the heart is the foundation on which past promises shall come to reality. I will build My congregation, the people of God. And because their hearts are right with Me, evil shall not be able to overcome them."

Dear Lord,

Thank You for the absolute certainty of Your promises. You have said You *will* build. As I look around, I see gloom and deadness. I hear conflicting pronouncements by those who teach in Your name. But Lord, *You build* that which will endure all the onslaughts of evil.

Forgive me for the many times I've yielded to discouragement. Forgive me my frustration when what I've tried to build hasn't worked. Teach me and Your servants everywhere that You are the Builder of what is lasting. Hold us steady in faith until we see evidence, in the lives we touch, that You have made Yourself known to them.

In Jesus' name, Amen.

10

A Partner with Heaven

"I will give you the keys of the kingdom of heaven; and whatever you shall bind on earth shall have been bound in heaven, and whatever you shall loose on earth shall have been loosed in heaven."

Matthew 16:19

It is humanly impossible to understand all that is implied in this amazing statement to Simon Peter. Reduced to its simplest terms it means heaven is pledged to stand behind, to ratify, to implement whatever Peter would say or do. It is God's declaration that He in heaven and His servants on earth would work in the harmony of a divine partnership.

This statement marks a climax in Jesus' dealings with Simon Peter. It is one thing to have the promise of a transformed character, or to know one's life will be fruitful in a God-appointed vocation. It is quite another to be given the promise of a partnership with heaven in building the kingdom.

To understand what Jesus meant we need to go back to a garden called Eden, and a newly created couple, named Adam and Eve. Different than all the creatures around them, wearing the stamp of the eternal, they were told by God Himself of their mission:

"Be fruitful and multiply, and fill the earth, and subdue it; and rule over the fish of the sea and over the birds of the sky, and over every living thing that moves on the earth" (Gen. 1:28).

Regents for God

To our first parents was given the task of ruling the world for God, as His regents. In spite of man's rebellion and his apostasy to God's archenemy, God has never retracted the responsibility He delegated.

History is one long demonstration of how thoroughly man's sin has distorted life, including man's purpose for being. Instead of being lord of creation, man became and is its slave. Even Nature drooped her wings and yielded to the divine curse which God imposed upon her.

And yet, in the midst of the darkness of sin's desolation, here and there we catch glimpses of God's intention still holding. So far as we are able to perceive, wherever or whenever God has moved significantly in men's affairs, some one or more of His children have prevailed in prayer for God to act as He did.

It was because of Abraham's intercession that God spared Lot and his family, just before judgment fell on the cities of the plain.

The history of the Jewish nation is filled with heart cries from people pleading God's intervention on their behalf. Before Moses was sent to lead them out of Egypt, the people of Israel "sighed because of the bondage, and they cried out; and their cry for help because of their bondage rose up to God. So God heard their groaning; and God remembered His covenant with Abraham, Isaac, and Jacob" (Ex. 2:23-24). Many times Moses pleaded with God on behalf of the stubborn, rebellious nation and secured mercy for them. A vivid example of this is after their sin of making a golden calf while Moses was on the mountain receiving God's Law. (See Exodus 32—34.) Many years later, the Amalekites fought with Israel on their journey from Egypt to Canaan. While Joshua and the army of Israel fought, Moses, Aaron, and Hur went to the hilltop to intercede for victory.

So it came about when Moses held his hand up, that Israel prevailed, and when he let his hand down, Amalek prevailed. But Moses' hands were heavy. Then they took a stone and put it under him, and he sat on it; and Aaron and Hur supported his hands, one on one side and one on the other. Thus his hands

were steady until the sun set. So Joshua overwhelmed Amalek and his people with the edge of the sword (Ex. 17:11-13).

There are many more examples of men decreeing, in intercessory prayer, what God should do. But the truth that God would act in concert with man is also specifically stated: "Thus says the Lord, the Holy One of Israel, and his Maker: 'Ask Me about the things to come concerning My sons, and you shall commit to Me the work of My hands' " (Isa. 45:11).

God lamented the absence of those who would fulfill their responsibility as intercessors for the needs of His people: "And I searched for a man among them who should build up the wall and stand in the gap before Me for the land, that I should not destroy it; but I found no one" (Ezek. 22:30).

Restored Relationship

But it was not until Jesus made His startling statement to Peter about the keys to the kingdom, that the full purpose of God for man was unveiled. Jesus was really saying that the restoration of a right relationship between man and God also restored man to the position he had with God before the Fall! While men of God had functioned in that capacity before, the basis for that function had remained hidden. Now, on the basis of knowing Jesus as God, and with His lordship in a man's life established, God would again entrust to such a person the responsibility originally delegated to mankind.

Peter wrote of this in his first letter:

You also, as living stones, are being built up as a spiritual house for a holy priesthood, to offer up spiritual sacrifices acceptable to God through Jesus Christ. . . . But you are a chosen race, a royal priesthood, a holy nation, a people for God's own possession, that you may proclaim the excellencies of Him who has called you out of darkness into His marvelous light (1 Peter 2:5, 9).

The same wondrous reality is sung about in heaven:

And they sang a new song, saying, "Worthy art Thou to take the book, and to break its seals; for Thou wast slain, and didst

purchase for God with Thy blood men from every tribe and tongue and people and nation. And Thou hast made them to be a kingdom and priests to our God; and they will reign upon the earth'' (Rev. 5:9-10).

Regal Authority

There are many ways to rule without using the external trappings of authority. Ruling by godly standards may look like weakness to man. The world sees only weakness in Jesus' submission to the Jewish leaders and to the Romans. As He was being ''led as a lamb to the slaughter,'' He was pitied and scorned because He appeared weak and totally helpless. But He was never more a king with total authority than when He hung on the cross. He requested of God and obtained forgiveness for His murderers. He opened the gates of paradise to a dying thief. He commanded His beloved disciple to become responsible for Mary, His mother. And when all things related to His sacrificial ordeal were completed, He demonstrated in one final act His supreme authority: He dismissed His spirit. In His dying He was indeed the King!

Men usually think of authority as outward, physical, related to status, resources, and ultimately to superior force over all under its power.

With God, authority and its function are in the realm of spirit. As Paul expressed it:

For though we walk in the flesh, we do not war according to the flesh, for the weapons of our warfare are not of the flesh, but divinely powerful for the destruction of fortresses. We are destroying speculations and every lofty thing raised up against the knowledge of God, and we are taking every thought captive to the obedience of Christ (2 Cor. 10:3-5).

Another example of the exercise of this authoritative priestly function is given us in Revelation 18:20: "Rejoice over her, O heaven, and you saints and apostles and prophets, because God has pronounced judgment for you against her."

The outpouring of God's wrath on the idolatrous and cruel world system described in Revelation 17—18 is attributed directly to the

heart declaration by God's servants that judgment must fall.

It is through the exercise of our God-given priestly function that the kingdom of God is extended in this world in the hearts of men. Here is the secret of the amazing advance of the Gospel of Christ during the first century A.D. The Christians understood the will of God; in believing, persistent, and authoritative prayer, they held before God those issues which they knew were His will; and in reverent insistence they decreed His will should be done.

In response to their faith and obedience, God fulfilled His promises, and acted in concert with their decisions. Thus, with all of heaven behind the church, how *could* it have failed?

Dear God,

I freely confess how slow I have been to understand Your ways. So much of my attention has been directed to schemes, plans, and programs designed to accomplish Your work. And yet, in spite of all the activity, the millions of dollars spent, the huge organizations created, the tide of sin rises ever higher until I've often feared the tidal waves of iniquity would sweep everything before it, including the church.

Grant us a life-changing awareness of Your way in building Your kingdom. Bring me, and my generation of Christians, to the place of persevering, believing, authoritative intercessory prayer; the kind of prayer the early church knew when it moved so effectively in the midst of the raw paganism of that day.

Teach us, dear Lord, something of what it means to function as partners with You in pursuing the fulfillment of Your revealed purposes in and through the church.

I praise You that all You have planned for our day shall be fulfilled and that we may have a part in this glorious partnership with You.

In Jesus' name, Amen.

Valley

11
Validate
Your Vision

From that time Jesus Christ began to show His disciples that He must go to Jerusalem, and suffer many things from the elders and chief priests and scribes, and be killed, and be raised up on the third day.

Matthew 16:21

Scene One was ending. The first great objective in Simon Peter's life had been achieved—Peter had been imbued with God-given vision.

All who have been effective for God have been people with vision. We will go only for what we *see*. The stature of a man, and the nature and extent of his work, are determined by the scope of his vision.

"Where there is no vision, the people are unrestrained" (Prov. 29:18). That is, there is nothing to hold them in a given direction, nothing to serve as a disciplining force to guide them toward a recognized goal. They exist merely for the satisfaction of momentary and purposeless desires. Nothing is so tragic as a life without vision.

God-Given Vision
God begins His work in all of us by imparting vision. Joseph dreamed his dreams. Moses, filled with vision, renounced the luxury of Egypt's court and identified himself with a race of slaves.

Joshua saw the giants in Canaan as opportunities for seeing God display His conquering power. Isaiah saw God as a mighty Monarch ruling in the temple, in spite of the formalism and spiritual deadness that already were evident to the young prophet.

Central to all God-given vision is the growing certainty of God's will and the assuring awareness that God is able and that He shall accomplish that will. This lifts the soul out of itself, above the deadening impact of the monotonous and the ordinary, and fills the present with purpose and the future with hope.

Since, however, it is possible to have vision that is only the dream of an excited mind, we need to *validate* vision by the teaching of Scripture. The Bible is the complete revelation of God's will for man and His purposes in time. All we need to know in this life about God's will, His ways, and His purposes is found in the Bible. It is stated either specifically or more generally in the form of principles. Some things are revealed by examples, some by inference, others by direct statement. There is room for flexibility, and the Holy Spirit may apply Scripture to situations in ways that we may not have thought of or aren't used to. But He will never apply Scripture so as to:

• Violate the holiness of God and essential godliness.
• Violate the basic law of love.
• Violate a good conscience.

Because some people go off the rails, following foolish and hurtful notions which they mistake for true God-given vision, others are overly cautious and even fearful. But we need not walk in fear. Jesus promised that those who follow Him shall not walk in darkness, but will have the light of indwelling life (John 8:12). If you are honest with yourself, with the Lord, and with the Scriptures as you meditate on them, you can trust the Holy Spirit to clarify to your own heart whether the vision forming and burning in your heart is of Him or something of your own fancy.

Realities of Vision

As with Simon Peter, God usually gives vision by accentuating to us the positive aspects of redemption. His promises grip us. We are

thrilled as we get glimpses of His divine purposes for our day. The negatives and problems of our time seem only to highlight God's overcoming power. And as we think about what God purposes to do in our day and time, we are energized by the wonder of having a distinct part in His plan.

In Jesus' early dealings with Simon, promise, encouragement, assurance, and winning invitation stand out so clearly. Simon was drawn ever deeper into a relationship of trust in Christ and commitment to Him.

We need to learn from this, for our tendency is to discount the reality of vision in ourselves and to disparage it in others. Conscious of those who are puffed up by ideas of their own importance, or aware of the exuberance and enthusiasm of young Christians, we are often too quick to pour water on what could well be a fire in the heart, kindled by the Holy Spirit.

Rather than offering a negative, discouraging response to one who speaks of his God-given vision, we need to respond with positive interest and encouragement. It means so much for a young Christian to feel older saints are interested in him, have confidence in his motives, and believe God wants to use him.

If a young person has confidence in his mature Christian friends, he will probably be open to wise and understanding counsel. He needs to be assured that God is continually seeking those who will accept vision from Him and will believe Him to fulfill it. A young Christian needs to be encouraged that God is no respecter of persons, but looks for receptive, trusting, humble, and obedient hearts rather than for people with great gifts or striking personalities.

A young Christian needs help in testing his vision against the teachings of the Bible. He should be encouraged to walk humbly yet boldly with God, to keep his heart tender, and to hold steady in the confidence that what is of God will stand examination.

Purpose for Vision

Think back in your own life. Did God at one time begin to fill your heart with vision? Perhaps He spoke of giving you a transformed

character. Maybe it was an inner certainty that He would lead you into a fruitful vocation. Or perhaps He spoke of greater things—like doing exploits in His name.

What did you do with the vision? Did you pursue it? Bury it? Refuse it? "The eyes of the Lord move to and fro throughout the earth that He may strongly support those whose heart is completely His" (2 Chron. 16:9).

Whatever you may have done about it, God wanted you to cultivate the vision, pursue it, believe in it. Today is not too late to start again. Go and talk to God about what you once dreamed of as an eager young Christian. He will not scold you. True, it may be too late to do what He spoke to you about then, but there are other aspects of vision He can give.

" 'And it shall be in the last days,' God says, 'that I will pour forth of My Spirit upon all mankind; and your sons and your daughters shall prophesy, and your young men shall see visions, and your old men shall dream dreams' " (Acts 2:17).

God has a purpose for every period of time in history, and for every person who will walk with God in his own generation.

Vision from God in any age is rooted in God's revelation of His purpose for that age. But the awareness of that purpose is given only to those who, like Simon Peter, leave all to follow Him, and to discover for themselves His mighty purposes.

Vision Leads to Fulfillment

Scene Two is beginning. The consummation of vision is fulfillment. With the heart enraptured, the soul on fire, the whole being vibrant with anticipation, one naturally looks for the excitement of fulfillment.

But—not yet! Abraham had a vision of being the progenitor of a multitude. But long years of weary waiting intervened before he became the father of the promised Isaac.

Joseph dreamed of leadership. Instead he experienced slavery and the agony of unjust imprisonment prior to his startling elevation to the premiership of Egypt.

Moses believed God was calling him to deliver His people. But

40 monotonous years of exile as a shepherd were to pass before the vision merged into reality.

The Hebrews were slaves in Egypt. In their agony they turned to God, and God gave them a vision of deliverance from the house of bondage to a land flowing with milk and honey. But between vision and fulfillment lay a burning desert and 40 long years of aimless wandering.

Jesus as a Boy of 12 was filled with vision of the things of His Father. But for the next 18 years He pursued the tasks of a Carpenter, in an obscure Galilean village.

The disciples on the mountaintop received a soul-captivating vision. "This Jesus, who has been taken up from you into heaven, will come in just the same way as you have watched Him go into heaven" (Acts 1:11). The early church believed this and was sustained and motivated by the vision of His return. They expected Him to come. But fulfillment still awaits. Almost 2,000 years have passed and He has not yet come.

Between Vision and Fulfillment
No, fulfillment does not follow immediately. And here is where so many people miss the way. They fail to see that *there must be an interim*.

Vision *captivates* the man. But before fulfillment can occur, *God must make His man*. It is the man himself who is to fulfill the vision. But no man produces beyond his own personal character. So God wisely, lovingly, patiently puts His man through the process of forming, so the man can become the fulfiller of the vision given by God.

It was at this point in Simon Peter's life that Christ's dealings with him changed, to begin the painful and often slow process of restructuring Peter's inward life.

Vision is not life nor accomplishment. Vision must be transformed into life by a process. That process takes time, circumstances, and the actual facing of life issues. The transformation and the restructuring of life occur as we meet the issues God puts before us in the crucible of real living—for it is there that we must actually

trust, deny self, and take personal steps of obedience that are contrary to our own way.

Valley of the Soul

This process in the soul's valley is often:
- nonglamorous.
- a dull, monotonous routine.
- unpleasant.
- contrary to natural desires.
- seemingly purposeless.

But when it is accepted as from God, it is:
- productive of Christian character.
- attended by a deepening awareness of God.
- a crucible that forges inner personal strength.
- God's way of molding His person.

The valley period is synonymous with the "hidden years" of godly people. Study the lives of all persons whom God has used significantly and ponder deeply the part played by the "hidden years" in each.

An individual must be willing to be "built" if he is to become the fulfiller of his vision. Many are not open to this process. We live in an age of instant gratification. Part of this syndrome is the urge to achieve quickly. Many grow weary early in the race and look for shortcuts to the goal.

Years ago I went to the Outer Hebrides Islands off the coast of Scotland to investigate a deep revival movement that was stirring so powerfully in those parts. In conversation with the Reverend Duncan Campbell, the man God was using, I asked if he had gone through any special experiences prior to his involvement with the work of God in the Hebrides.

"Yes," he said, "I did. I went through a period of intense suffering, such as I hope no other man shall have to endure."

It is always this way. For a man's message is projected through his life. Are you willing to let God form you? If so, you can learn a little of what it means, by following this next period in Christ's dealings with His servant, Simon Peter.

Dear heavenly Father,

Thank You for condescending to give vision to man. Clarify for me the vision You have given or wish to give to me. Don't let me hold it lightly, reject it in fear, or become puffed up by it. Rather help me daily to trust You to bring about fulfillment in Your way and time. Enable me to see each circumstance as an instrument in Your hand for building me into the person I must be to fulfill the vision.

Daily remind me that salvation and vision have come to my heart for something much greater than my own happiness or good. Keep me steadily pursuing with patience the race set before me, even through the valley.

In Jesus' name, Amen.

12

Peter, You're in My Way!

Peter took Him aside and began to rebuke Him, saying, "God forbid it, Lord! This shall never happen to You." But He turned and said to Peter, "Get behind Me, Satan! You are a stumbling block to Me; for you are not setting your mind on God's interests, but man's."

Matthew 16:22-23

Try to put yourself in Peter's place. He had been given supernatural illumination to know that Jesus is God. Jesus had declared that heaven would stand behind Peter's decrees. Now Christ was talking about His death. That meant defeat, whereas a short while before He had spoken so glowingly of glorious triumph. You don't build kingdoms by dying! *Or do you*?

No, something was wrong. Jesus seemed to have missed the point. Everything in Simon Peter recoiled at the prospect that Jesus would fail. Why, He talked as though He would deliberately give in to those hateful religious leaders in Judea.

No! No! And as Peter's feelings rose to highly pitched intensity, he stepped in to contradict and correct his Lord.

"Master, we will never let You do this!" In that brief sentence Simon Peter put himself squarely in the way of Jesus Christ.

Swiftly came the shocking reply: "Get behind me, Satan. You are a stumbling block. You think like men, but not like God.

"Simon, your whole outlook is twisted. You are looking at life

from fallen man's point of view. And in the degree that anyone acts from that perspective, he is a tool of My archenemy, Satan!''

What Happened in Eden?

The implications of man's fall in the Garden of Eden are but superficially perceived by most of us. We tend to be simplistic in our understanding of man's sin and of what is necessary for his salvation. Since redemption must at least rectify the damage done by man's fall, it is imperative that we understand clearly what really happened on that fateful, tragic day.

Adam did much more than disobey a seemingly trivial command to abstain from eating the fruit of a certain tree. The effects of what our first parents did have dominated every living soul all the way to this present hour.

1. Man accepted Satan's lie that God is untrue.
"Dear Eve," he said, "don't you know that God has lied to you about this tree? You won't die if you eat its fruit, as God has threatened. You will live."

In that moment the virus of unbelief was planted in the human heart and implicit trust was shattered. Suspicion of God's character began. Ever since then it has been extremely difficult for man to really trust God. Since trust is basic to any harmonious relationship, heaven is impossible for any person who cannot trust God's character implicitly.

2. Man accepted Satan's lie that to get ahead in life one must put self-interest above any other concern.
"Eve, don't you realize that by eating this fruit you will be like God? You will be *someone*, Eve. After all, you need to look after your own interests. No one else will. As for this God, He is only keeping you from true self-fulfillment."

There was born in man's heart that day the deceptive idea that the way to succeeed in life is to climb, at any cost, and regardless of what may happen to others. "Look out for yourself, man. No one else will," is a ruling principle of every life. It takes a miracle of divine grace to deliver any of us from the tyranny of that foul principle.

*3. Man accepted the lie that true satisfaction and security are
to be found in the created, the seen, the tangible, rather than in the
Creator, the unseen, the intangible.*

"When the woman saw that the tree was good for food, and that it
was a delight to the eyes, and that the tree was desirable to make
one wise, she took from its fruit and ate" (Gen. 3:6).

On that day man's values were turned upside down. The satis-
faction of physical appetite, esthetic and emotional gratification,
and pride in a feeling of importance and self-worth assumed an
importance to man that would become deadly. Man became a slave
to himself. Man's body, which was created to be his servant,
became a tyrannical master.

Plunge into Death

History is one long and vivid demonstration of the living death into
which our first parents plunged our race. Every succeeding genera-
tion has written its own chapter of agonizing, but futile attempts by
man to find lasting contentment. Self is a driving and ruthless
master. The more it is served, the more it demands. Its wages can
never be less than death.

Because of the depth and totality of man's inner distortion, so
spontaneously and profoundly expressed in Simon's rebuke of his
Master, Jesus had to cut Simon to the quick.

"Get behind Me—Satan!" What a devastating blow! And com-
ing as it did right on the heels of such profound and exhilarating
statements as "Thou art a rock," and "Whatever you bind on earth
will be bound in heaven, and whatever you loose on earth shall be
loosed in heaven."

Peter's Spirit-forged relationship to Jesus Christ is what made
such a shattering statement imperative: "Get behind Me—Satan."
The divine Surgeon was laying open the hidden cancer with one
sure, swift stroke of the scalpel. The surgery must be drastic if it is
to be effective.

While Christ directed His harsh rebuke to Simon Peter, He
turned to the whole group to explain *why* He had spoken as He did:

"If any one wishes to come after Me, let him deny himself, and

take up his cross, and follow Me. For whoever wishes to save his life shall lose it; but whoever loses his life for My sake shall find it. For what will a man be profited, if he gains the whole world, and forfeits his soul? Or what will a man give in exchange for his soul? For the Son of Man is going to come in the glory of His Father with His angels; and will then recompense every man according to his deeds" (Matt. 16:24-27).

What Jesus had said by way of rebuke to Peter, He now applied to all the disciples—and through them to you and me. Relationship to Him must involve a coming to grips with our internal distortion. Without this there can be no ultimate salvation, because Christ and self cannot coexist as equal lords.

The damage done in the Garden of Eden must be repaired through redemption. Self must become your servant instead of your master. The way to live is not to assert yourself, but to yield to the lordship of Christ, even if that yielding costs you your life.

Never lose sight of the fact that any perceived relationship to Jesus Christ which fails to issue in progressive internal transformation of life is an abortive relationship.

Internal transformation involves a denial of self, a daily taking up of one's cross, and an ongoing, persistent following of Him. When your relationship to Christ is a genuine reality, built on a growing, deepening faith that the Holy Spirit has engendered, you will welcome the implications and demands of that relationship.

Peter did not reject the rebuke of his Master. Rather, he took it as it came and became a stronger disciple for it. It is when you ignore or reject the "valley dealings" of the Lord that you are in trouble.

And if you ever begin to tell yourself, "I am still quite safe as a Christian, even if I don't follow Him wholly," you are in deep trouble.

Dear heavenly Father,

Help me to see clearly the profound and eternal issues implicit in Your sharp rebuke to Peter. How superficial and simplistic have been my ideas about sin and redemption. How little I have realized the depth of my own sinfulness, the strength of my desire to take

the popular road, and the extent of what You need to do in me.

I am quite sure I'll do as Peter did, when following You leads to a cross. Like him I'll probably say, "Not so, Lord." In Your love and faithfulness, You won't withhold the rebuke. Rather, You will deal with that deadly self in me to which I am so utterly blind.

In Jesus' name, Amen.

13

God Is More Than Splendor

And He was transfigured before them; and His face shone like the sun, and His garments became as white as light. And behold, Moses and Elijah appeared to them, talking with Him.

And Peter answered and said to Jesus, "Lord, it is good for us to be here; if You wish, I will make three tabernacles here, one for You, and one for Moses, and one for Elijah."

While he was still speaking, behold, a bright cloud overshadowed them; and behold, a voice out of the cloud, saying, "This is My beloved Son, with whom I am well-pleased; hear Him!"

And when the disciples heard this, they fell on their faces and were much afraid. And Jesus came to them and touched them and said, "Arise, and do not be afraid." And lifting up their eyes, they saw no one, except Jesus Himself alone.

Matthew 17:2-8

The scene beggars description. The Man Jesus, with whom they had walked, talked, eaten, slept, prayed, and wept, suddenly became the Lord of glory. The dazzling splendor of the celestial world enveloped His whole being. His plain garments and the familiar features of His human form became radiant with the blinding brightness of heavenly light.

Engaged in earnest conversation with Jesus about His impending death were two of the most revered heroes of the Jewish nation:

Moses, the lawgiver, and Elijah, the prince of the prophets. All of history was focused on this one climactic moment that revolved around a glorious Person and His impending agony on a blood-stained cross.

Peter, James, and John were overcome. Man, unaided by divine enablement, cannot stand the unveiling of the eternal world. We live in the shadows, where all that we see is momentary and passing. But in this transient dream we are at home, in spite of suffering, injustice, disease, and death.

Man is at home in this world—and yet not at home. No man really wants to die. How desperately we pray for physical healing. How reluctant we are to see loved ones leave us. Some people will follow anyone who can prolong their earthly lives.

But there on the mountaintop, heaven had broken through. Men long dead were seen to be very much alive—and intensely involved in the great realities of redemption about to happen.

It was Peter who spoke. In his Gospel, Luke wrote that Peter didn't know what he was saying. But isn't that our way? When we don't know what to say, we still say something!

"Lord, this is wonderful! If you will permit me, I will memorialize this place and this moment. I will build three memorial shrines, one for You, one for Moses, and one for Elijah. And then we can stay here and worship."

Quietly and effectively God responded to the excited disciple. First there was a cloud, then a voice with its gentle rebuke: "This is My beloved Son . . . listen to Him."

The splendor, the glory, and the heavenly visitors disappeared. And the three disciples were alone with Jesus!

The Experience of Glory

God in His wisdom and mercy gives to some believers the thrilling experience of tasting heavenly glory while yet on earth. Moses pleaded with God, "Show me Thy glory" (Ex. 33:18). Elisha, Isaiah, Ezekiel, Daniel, the shepherds, Stephen, Saul of Tarsus, and others down through history have been given momentary glimpses of the realities of the eternal world.

But few are able to handle experiences which are out of the ordinary. The Apostle Paul said of himself, "Because of the surpassing greatness of the revelations . . . to keep me from exalting myself, there was given me a thorn in the flesh, a messenger of Satan to buffet me—to keep me from exalting myself!" (2 Cor. 12:7)

As valuable as such glorious experiences are, we must not attach an importance to them beyond what God intended, nor be puffed up with pride when they are given to us.

But there is another and more subtle danger to which all of us are prone. It is the danger of assuming God is more or less present in our lives and circumstances according to the degree of "glory" we feel at any given time. Jesus was not *more* God at the Transfiguration. He was just as truly the Lord of glory when walking the dusty roads of Galilee as He was when talking to Moses and Elijah on the Mount of Transfiguration.

The Godliness of God

There are some things God can lay aside and still be God. Among these are His blinding splendor, His display of heavenly glory—those things which so attract, fascinate, and captivate man. Kings, rulers, and great men of every age have sought to express their greatness by some degree of splendor in dress, equipage, and style of living. Man has always associated these with greatness. The pomp and pageantry of history appeal strongly to our nature, and we want our God to be that way too.

But there are other factors God can never dispense with and still remain God. Chief among these is His spotless character. In whatever dress He may appear, it will always be preeminently a garment of godliness. Whether as the meek and innocent Lamb, the humble Shepherd, or the Lion of Judah—God will *always* be godly!

Godly character is not usually very important to us. Many who aspire after exciting experiences of God in their lives give little thought to true Christian character. It is thrilling to have the soul swept by feelings of heavenly glory, but often not so exciting to

consistently speak the truth, be dependable on the job, or take personal injustice patiently.

Glory Calls for Preeminence

No, Peter, don't get caught up in the glory. Accept it but keep your heart's ear open to listen to Jesus regardless of His appearance.

Peter wanted to build *three* memorial shrines, and so would you or I. The overpowering effect of glory takes man off balance. It is not Jesus, Moses, *and* Elijah that are central to God's kingdom. One, and only One shall ever have preeminence, the Lord Jesus Christ. If we construct a memorial shrine, it has to be only one, not three! Moses and Elijah spoke of Christ. Let all of us listen only to *Him!*

Then too, this was not the time for shrine building. There was a death to die in Jerusalem, eternal redemption to be effected, and a weary, sin-filled humanity to be brought to the Saviour's feet.

Peter never forgot that glorious moment on the mountain. He spoke of it in tones of awe in his second epistle (2 Peter 1:16-18), written a short while before his death. He had learned, as all of us need to, that our God is more than an experience, and greater than any glory. Our relationship to Him should always be more real than any religious experience or expression. If our relationship to God fluctuates in proportion to our experience of the splendor, then we are on shaky ground. Each of us must learn to live by faith in response to all that the Father meant by those solemn words:

"This is My beloved Son, with whom I am well pleased; *hear Him.*"

"And looking up, they saw no one, except Jesus Himself alone."

Dear Father in heaven,

Thank You for every time You have unveiled to any of Your servants something of the glories of heaven. And thank You for those times when You have allowed me to feel You very present with me.

I am aware of the temptation to want the glory and splendor for

their own sake, to envy those who experience them, and to feel let down when I don't have them.

Teach me to walk by faith, and to love You for Your holy character and justice, as well as Your mercy. Help me to love You as a God who hates sin as well as the God who loves the sinner.

Let me be delighted and content to walk with You in the paths of daily duty, even if they never lead to a Mount of Transfiguration. May I value steadfastness and self-giving service more than spiritual ecstasies.

In Jesus' name, Amen.

14

Forgiveness Doesn't Keep Records

Then Peter came and said to Him, "Lord, how often shall my brother sin against me and I forgive him? Up to seven times?" Jesus said to him, "I do not say to you, up to seven times, but up to seventy times seven."

Matthew 18:21-22

Jesus had been teaching His disciples about the problem of sin in their fellowship, and how His followers should deal with an unrepentant brother. He had used very strong language, even saying that discipline by as few as two people, when backed by believing prayer, would be ratified by heaven. In other words, discipline of an offending brother was not merely a legally implemented action taken after a majority vote by a congregation. True discipline is a spiritual dynamic involving the concurrence of the church on earth and the Lord of the church in heaven.

Following this teaching, Peter came to Jesus with a personal question.

"Lord, how often shall my brother sin against me, and I forgive him? Up to seven times?"

Does Forgiveness Contribute to Delinquency?
Did you ever try forgiving someone seven times? Try it.

Let your husband or wife say an unkind word to you once. Then you forgive. Twice. You forgive again. The third time. Do you

still forgive? Let the offense go on—once each day for a solid week.

We have a saying, "Third time's a charm." Most of us do well if we can manage three acts of forgiveness in a row, to say nothing about seven!

Do you know what automatically happens when we are faced with repeated wrongs by the same person, each one calling for an act of forgiveness? By about the third time we conclude that continued forgiveness will only contribute to the other person's delinquency, and confirm him in his bad deeds. We are apt to start making some conditions for our forgiveness, like:

• "When you begin to change, then I'll forgive you."

• "OK, this is the last time, I'm tired of hearing your apologies. You need to change."

Is it possible that someone was a bother to Peter? Did he feel he'd really gone all the way by extending forgiveness not three, but *seven* times? Wouldn't *you* feel pretty spiritual in such a case? I'm sure I would.

But how much more pointed could Jesus be in His reply to Peter?

"Not seven times, Peter, but four hundred and ninety times. You see, in the kingdom of God we don't keep records. As long as you keep a record of the number of times you forgive, then you aren't forgiving. Forgiveness comes from the heart and is rooted in attitudes, not in legal limits. So Peter, if you are going to keep records, get a book and keep on recording until you get tired of it."

Jesus then told a story of a forgiving king and an unforgiving servant. He concluded with the heart-searching declaration that salvation is impossible for any person who does not have a forgiving spirit.

God has freely forgiven the enormous debt I owe Him. If His forgiveness does not beget a forgiving spirit in me toward those who owe me trifles by comparison to my debt, then God's love and mercy have been expended on me in vain.

What Is the Purpose of Forgiveness?
There is a fundamental law in the kingdom of God—whatever God

gives to any human heart is intended to conform that heart to the nature of the gift. Mercy granted by God produces in man a merciful spirit. Love given makes the soul loving. Patience granted makes the person patient. And forgiveness extended makes the recipient forgiving.

Wherever and whenever the blessing of God fails to effect an appropriate change in the heart, then the blessing becomes a curse, an instrument of deeper damnation rather than of redemption.

Forgiveness is a part of God's holy nature. Never in all of history has that fact been more vividly and fully expressed than when God's Son uttered these words from a Roman cross:

"Father, forgive them; for they do not know what they are doing" (Luke 23:34).

Forgiveness in Our Age?

His kingdom must be characterized by a holy spirit of forgiveness. But we live in a turbulent age. There is an emphasis on fighting for one's personal rights. And the more we insist on our rights, the more we and others get hurt in the process. Little is heard today of "going the second mile," "enduring wrongs patiently," or of being "harmonious, sympathetic, brotherly, kindhearted, and humble in spirit; not returning evil for evil, or insult for insult, but giving a blessing instead" (1 Peter 3:8-9).

Added to the problem are the mobility, transience, and increasing impersonalization of society. We move so often. And many of us feel far too alone personally to want to live closely with those we would need to forgive, or from whom we would need forgiveness. The result is that many resentments become buried deep within the heart, seemingly forgotten. Since the circumstance that occasioned the hurt is distant, the lack of forgiveness goes unnoticed.

Think back over your past. Do you have a forgiving heart? People have hurt you—parents, children, husband, wife, lover, pastor, fellow Christian, neighbor, or friend. The hurt may be real and deep. You may have been totally wronged, or you may have imagined part of it. The question is, are you still carrying the hurt?

Who can tell the degree to which Christians' hearts are

hardened, the Holy Spirit grieved, and the work of redemption thwarted, by people harboring unforgiving spirits? The effects are so subtle and often imperceptible at first. People's testimonies, belief of the truth, and superficial evidences of being Christian may remain intact. But the hidden cancers remain. Unless God's grace melts their hearts sufficiently to cause forgiveness to flow toward *all* those who have hurt them, there can be no final acquittal of guilt by a holy God.

Not seven times, Peter! Forgiveness doesn't keep books. It's a *forgiving spirit* you need. Let God keep the books and deal with the repeating offender. But you "watch over your heart with all diligence, for from it flow the springs of life" (Prov. 4:23).

Dear God,

I confess my sin of treating lightly many of Your most solemn declarations, including the imperative of a forgiving spirit.

I feel my need of an ever-deepening awareness of how much You have forgiven me. Without this I'll continue to keep records of the number of times I have forgiven, rather than having a forgiving spirit that comes from You.

A forgiving heart is what I need, and what I choose to trust You for. You have promised to work this fruit of the Spirit in all who really believe in You. And in this promise I rest, expectantly.

In Jesus' name, Amen.

15
What Do I Get Out of It?

Then Peter answered and said to Him, "Behold, we have left everything and followed You; what then will there be for us?"
Matthew 19:27

Try to put yourself in the disciples' place. They had left all to follow Jesus, for they were increasingly sure that He was the promised Messiah of Israel. But there were things about Him that left them completely puzzled.

They saw no evidence that He was building a band of trained revolutionaries to lead a revolt against the Romans. But perhaps He would deal with them as Moses had dealt with the Egyptians— by calling plagues from heaven upon them.

Nor did He indicate any intention of unseating the arrogant clique centered in the corrupt high priest and his followers. Surely, if Jesus were the Messiah, He would fulfill Malachi's prophecy of purification for the sons of Levi, so that godliness would characterize the priesthood and the temple system.

Instead of discussing strategy for dealing with these two most pressing thorns in Israel's side, Jesus' interests and conversation kept turning in a totally different direction. More and more He talked about martyrdom. He acted as if He would voluntarily allow Himself to be humiliated, beaten, and killed by the hated religious rulers in Jerusalem. His concerns seemed to focus increasingly on a kingdom in another world.

You Need Money to Live

To what, the disciples must have wondered, had they really committed themselves? They had gained no material advantage by following Jesus. He didn't seem interested in that side of life. True they hadn't starved, but there never seemed to be anything to fall back on either. In fact, it was somewhat humiliating for strong, able-bodied men like themselves to have to depend on the generosity of those who chose to contribute to their cause. Some of their chief supporters were women, at least one of whom was known to have rather questionable background—Mary Magdalene, out of whom Jesus had cast seven demons.

Within their own organization, some of the disciples may have questioned the way the money was handled. Judas' financial reports were at times vague and incomplete, and it didn't seem to bother Jesus that the treasury was empty more often than not.

The climax came one day when a wealthy young nobleman came to Jesus and asked how he might have eternal life. Jesus told the young man to sell everything he had and give the proceeds— not into their treasury—but to the poor! And then, with *nothing* to support himself or them, he was to join their small band, sharing in the common purse to which he had contributed nothing. Jesus concluded the talk by assuring the man that he would have treasures in heaven!

There it was again. With all that they needed for daily living, and with what it would surely require to finance a successful revolution, Jesus seemed deliberately indifferent to a golden opportunity for acquiring badly needed funds. When the young rich man hesitated and then refused the terms, Jesus didn't even persuade him to reconsider!

The "I" Factor

Is it any wonder that Peter asked that penetrating question— "What then shall *we* have?" They had left all to follow Christ, but what was in it for them? Let Christ be as visionary as He wished. Let *Him* be homeless, penniless, friendless, if He chose to be. But did that mean they had to serve for nothing? When adequate funds

could have been had for the asking, Jesus in effect had said, "I don't want your money. Go and give it all to the poor, and come, join us empty-handed!"

Of the many areas with which redemption must deal, none is more subtle or difficult than the question, "What's in it for me?" This is especially a problem for the totally committed, the very conscientious, the faithful, hardworking, self-sacrificing Christian. How often one hears that question—asked in many ways and by people from whom one least expects it. At root is the critical "I" factor in Christian life and service.

A missionary candidate and I discussed the question of a "martyr spirit" in Christian workers. I asked if she had ever experienced it. A few years later she wrote me from the field:

"Do you remember our talk about a 'martyr spirit'? Well, I've had it all right. At the end of a long, hot day, it came over me completely. 'Nobody cares. What am I getting out of all this self-giving? I'm just taken for granted. Poor me!' You know, I just sat down and bawled!"

Stop and think of all the Christian service that's rendered by faithful Christians and for which no recognition or praise is given. I think of a little old lady who faithfully picked up gum and candy wrappers around a Christian campus. She wasn't paid for her work nor honored in college chapel. Does your church have a special service each year to honor the custodian? Or what about the few ladies who regularly stay to clean up after church suppers, when all the others have left?

The list could go on and on. And in some way most of us have been there. Does Peter's question find an echo in your heart?

Accolades are given to the great. People sing to heroes. The achievers and the charmers are recognized and rewarded. But for every person in the limelight, there are hundreds who live and love and serve unknown and unrewarded.

Left undealt with, this "I" factor will totally corrupt. It is the seed from which springs the root of bitterness. Its end is death, not only to the individual, but to all the individual touches. Behind many a Christian smile, within some Christian organizations, and

subconsciously permeating many glowing testimonies for Christ, there is a deadly and unrecognized cancer of personal self-seeking. This is what was revealed by Peter's honest question.

God's Bookkeeping

"Yes, Peter, you will receive something," replied Jesus. "You will get plenty and more. Not a single step of sacrifice goes unnoticed.

"But remember, the accounts are kept differently over there. Many shall be last there who are first here, and first there who are last here. My kingdom is not of this world nor of this order. What is approved here by men is often abominable to God. And what men hate and despise here is often just what God approves and rewards. Oh, Peter, how much you need to see life through heaven's eyes!"

You and I need that same transferral of vision. Is it wrong to get? Is it wrong to be rewarded? No. But to lust for reward, to be corrupted through coveting, or to become bitter when we don't receive recognition is sin.

Your life and service must be with a single eye—done as unto Him, "not by way of eyeservice, as men-pleasers, but as slaves of Christ, doing the will of God from the heart" (Eph. 6:6). If you are rewarded, give thanks. If not, leave your case with Him who keeps accurate books.

Does this mean that as a Christian you should not be paid for work done? Of course not. But it means you must keep your spirit right, and this will be possible *only* as God, through "valley experiences," deals with your hidden motives, until increasingly you are contented to be serving Jesus Christ alone. Serving, not for what you may get, but for the pure privilege of being one of His unworthy servants.

Dear heavenly Father,

Sometimes I feel totally confused as I look at Your work. Money, talent, ability, the right personality, and the proper academic degrees all seem so important. It seems that Christian service has to be so big, bold, and successful. Millions of dollars

are constantly needed for huge organizations whose leaders are gifted, competent, and sure of themselves.

We seem so far away from Your Son who lived simply, yes poorly, with a small group of rustic disciples. Surely there must be many who are tempted to ask Peter's question. I find it springing up in my own mind and heart. And what about the many little people in Your service, who aren't seen or applauded?

Oh, heavenly Father, deal effectively with whatever remains of an uncrucified "I" factor in my life and service. Let my eye be single and my motives crystal clear, so that I may live true to Your values and Your eternal goals.

What I pray for myself I pray for others. Set free those who are tempted to secret covetousness, and meet their deepest heart needs.

In Jesus' name, Amen.

16

How Do You Measure Greatness?

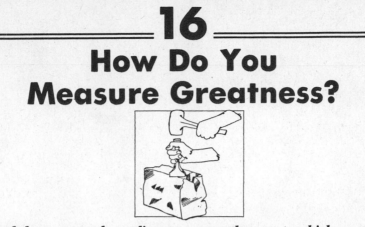

And there arose also a dispute among them as to which one of them was regarded to be greatest.

Luke 22:24

Then He poured water into the basin, and began to wash the disciples' feet. . . . He came to Simon Peter.

He said to Him, "Lord, do You wash my feet?"

Jesus answered and said to him, "What I do you do not realize now; but you shall understand hereafter."

Peter said to Him, "Never shall You wash my feet!"

Jesus answered him, "If I do not wash you, you have no part with Me. . . . You call Me Teacher and Lord; and you are right; for so I am. If I then, the Lord and the Teacher, washed your feet, you also ought to wash one another's feet."

John 13:5-8, 13-14

The disciples believed that Jesus was going to reinstate David's kingdom, and that they would occupy positions of prominence and influence. Within their commitment to Jesus lurked deep-seated rivalries, particularly among the inner circle. Who would be given coveted positions of higher rank? Periodically these deep feelings broke out into heated discussion or open quarreling.

Position, Power, and Prestige

You and I are no different. We all are concerned in various ways about position, power, and prestige. Man was created to rule. (See

Genesis 1:28.) But ever since the Fall, man's idea of greatness has been distorted. We think greatness means having the power and authority to *command* others. God thinks of greatness in terms of *serving*. In the kingdom of God he is greatest who serves the most. Here is one of the fundamental differences between the kingdom of God and earthly organizations and kingdoms. In spite of the instruction Jesus had given about true greatness, it took the mighty power of the Holy Spirit, unleashed at Pentecost, to effect the needed radical change in the disciples' thinking and inner aspirations.

A recent incident had brought the issue clearly into the open. The mother of James and John had been so bold as to ask Jesus to give her sons top positions in His coming kingdom. Because this made the others furious, it opened the way for Jesus to explain again the marked difference between man's way of doing things and God's.

"You know that the rulers of the Gentiles lord it over them, and their great men exercise authority over them. It is not so among you, but whoever wishes to become great among you shall be your servant, and whoever wishes to be first among you shall be your slave; just as the Son of Man did not come to be served, but to serve, and to give His life a ransom for many" (Matt. 20:25-28).

Now they were at it again. In the Upper Room and during the Passover meal, the disciples renewed the touchy subject until it flared into a heated argument. They must have felt the time was near for Jesus to make some startling move and proclaim His kingdom.

The common people believed He had already announced Himself their king. It was hard to see any other meaning in the tumultuous welcome given Him by the masses only a few days before. He had not refused their hosannas but had rebuked the religious rulers for demanding that He silence the excited travelers crowding into the city.

What a day that had been! In the tradition of Israel's ancient kings, astride a lowly donkey, Jesus had ridden triumphantly into

the capital. The acclaim had been thunderous, and Jesus' acceptance of their adulation seemed complete.

Surely the critical moment had come. Whom would He appoint as His prime minister, secretary of defense, and lord of the treasury? But this night their argument was not about who might be appointed, but about who was really the greatest, and as such deserved the highest position?

Jesus listened quietly but sadly. He knew the hearts of the men present and loved them deeply, even though one had already chosen to turn traitor. How could He teach them?

Near the door were water, a basin, and towels ready for a household servant to use in washing the feet of guests as they entered the room. On this evening there was no servant, since they had requested the use of the room only, without obligating the master of the large house. Someone in the group should have volunteered to do the work of a servant and wash the feet of the guests as they had entered. But not one of the disciples had offered, and their argument about greatness made it clear that doing servant's work was the farthest thing from their minds.

Jesus was particularly concerned about Simon Peter. Coming through in the argument, Jesus could perceive a note of arrogance and superiority in Peter's voice and attitude.

Jesus knew Peter some day would occupy a place of prominence in the church. But there persisted in his makeup a fatal flaw. He had a deeply rooted streak of self-confidence that was built on his own estimate of himself rather than on his confidence in Jesus' power and sufficiency in him. It was a carnal, fleshly self-assurance that could never stand the tests of real life or have any place in Christ's kingdom.

The Greatest One at Work

Very quietly Jesus arose from His couch, slipped off His robe, tied a towel around His waist, poured water into a basin, and began to wash the feet of His disciples. He took upon Himself the work of a common household slave.

The arguing stopped abruptly and the room became strangely

silent. The only sound was the splashing of water as Jesus moved from disciple to disciple. He worked quietly, without a word of explanation. As He came to Peter, the silence was suddenly broken, as Peter said,

"Are You going to wash *my* feet?"

"I'll explain later," replied Jesus.

"You'll never wash *my* feet!" exclaimed Peter.

Why the strong reaction from Peter? Could it be that his conscience had been stung, as he realized none of the disciples including himself had even thought to do the work of the missing servant? And that their acknowledged Master was doing what any one of them should have done?

But the gall of the other disciples! Each in turn had let Jesus act as a common slave to him, without a word of protest! Peter's heart was filled with scorn. At least he wouldn't be that small. It was *he* who should be serving his Master.

"No, Lord, You won't wash *my* feet!"

The reply came gently. "I'm sorry, Peter. If you won't let Me do servant's work for you, then there's no relationship between us."

What a blow! God serving man? Man being waited on by the Lord of eternity? The arrogance in Peter's spirit faded. If relationship meant self-humbling to the point of being served by his Lord, he was willing. More than willing.

"Lord, then do more than my feet. Wash my hands and my head as well."

"Peter, I'm not worrying about you being clean," replied Jesus. "A man who has bathed doesn't need to wash, but is clean all over. And you men are clean, all but one of you."

Greatness Roots in Serving

After completing His self-appointed task, Jesus returned to His place and took up the subject about which the disciples had argued. He explained again that true greatness is rooted in serving, not in being served. The heart of redemption is in God giving Himself for man—the Creator serving the creature. It is divine love in action, a

love demonstrated on the cross where Jesus gave Himself as a ransom for many.

While this is quite easy to accept as doctrine, it takes a miracle of God to enable us to practice it in daily living.

There is a hidden factor in this definition of true greatness, which is easy to miss. Many will give themselves unstintingly in a conscious effort to be great, by doing deeds of self-sacrifice. Whole religious movements have been built on this. But they miss the key, the kernel, the heart.

Self-Giving Love

True greatness is service to others *because we love them*, and for no other reason. This love moved the Father to send the Son. This love moved the Son to give Himself in total self-giving, even to the humiliating, agonizing death on the cross, with the Father's face turned away, and the burden of a world's sin on His sinless soul. And this love sent the Holy Spirit to strive with sinners and to dwell in incredibly weak saints.

Self-giving love reflects the harmony and perfection of heaven. Nobody there worries about position, power, or prestige. All live to serve, each counting the other better than himself. The principle that it is more blessed to give than to receive is so foreign to human nature.

How shall we learn this which is so contrary to our nature? It is not something we can produce by strong declarations, firm acts of the will, or various programs of studied servanthood. Christ alone, by the power of the Holy Spirit, can do it. Our part is to trust Him expectantly. He will work while we trust. And usually His working will come as unexpectedly and as effectively as it came to Peter in the Upper Room. It may catch us off guard, just as Jesus caught Peter completely off guard, by insisting that self-confident Peter let Jesus do what He loved to do—serve out of love.

You and I must learn to let God work His redeeming miracles in us in His way and in His time—for He won't bother to consult us beforehand. Our job is to trust, and then when He does work, to respond.

Dear Lord,

I've surely wanted to be known as great. All too often I've envied those in places of position and power, even resenting that I was not where they are.

My distorted concept of greatness is deeply rooted. I know the truth in my head, and with my will I accept it. But to perform what I've willed is something else again.

How totally lost I would be, if it weren't for Your great redemption. Thank You for showing that I don't have to re-create myself. My job is to trust You, and I do just that, dear Lord.

I praise You that You are working even now in all sorts of ways, many unknown to me, to develop in me a desire to serve out of love.

In Jesus' name, Amen.

17
Go Ahead, Satan

Simon Peter said to Him, "Lord, where are You going?"

Jesus answered, "Where I go, you cannot follow Me now; but you shall follow later."

Peter said to Him, "Lord, why can I not follow You right now? I will lay down my life for You."

Jesus answered, "Will you lay down Your life for Me? Truly, truly, I say to you, a cock shall not crow, until you deny Me three times."

John 13:36-38

"Simon, Simon, behold Satan has demanded permission to sift you like wheat; but I have prayed for you, that your faith may not fail; and you, when once you have turned again, strengthen your brothers."

Luke 22:31-32

Following the Passover feast and the departure of Judas to pursue his betrayal, Jesus began His farewell talk to His disciples. While they must have sensed the gravity in Jesus' manner and speech, the tension in Jerusalem, and the rising waves of bitter hostility toward their Master by the Jewish leaders, they had no idea that in a few hours He would surrender Himself to their grasp and will.

The Kingdom
In spite of all that Jesus had said about His coming sufferings and death, their understanding was still dark. To them the kingdom of

God was still an earthly and tangible kingdom, with power suffi-
cient to suppress evil, establish justice, relieve the oppressed,
subdue enemies, and rule the world for God and for good.

The disciples had little or no awareness that God's kingdom is of
a different order. While the kingdom of God co-exists with this
physical world, its structure, values, guiding principles, and
sphere of operation far transcend our earthly realm and human
senses.

Basic to the disciples' blindness was the stubborn truth that the
natural man, no matter how well instructed his mind or how keen
his native perception, cannot know the things of the Spirit of God.
To live in God's kingdom requires an ongoing miracle by which
the recipient is brought into an ever-increasing awareness of and
commitment to the realities of the unseen but eternal world of the
kingdom.

Simon Peter and the other disciples had received glimpses of
that kingdom. Their relationship to Jesus Christ was genuine, and
so was their membership in His kingdom. But their development
into effective servants in His kingdom would require degrees of
internal heart-change of which the disciples were unaware.

Nothing is more devastating to the human spirit than the discov-
ery of one's total personal helplessness. The root of man's sin is
desire for independence from God. Self-sufficiency is the goal of
every person born into this world. Even those who wish only to do
good for others desire to perform the good from the reservoir of
their own resources. At the root of every man's being is the need to
be adequate within himself.

Dependence

The kingdom of God is built from dependence. This dependence is
demonstrated to us by the interdependence within the Godhead, as
God the Father depended on the voluntary willingness of the Son to
allow Himself to be the sacrificial Lamb so that man could be
redeemed. God the Son revealed this interdependence in His
earthly life by His undeviating dependence on His heavenly
Father. And God the Holy Spirit carries out His age-long ministry

to the church on earth in constant dependence on the Son in heaven.

Dependence is the very spirit of heaven. Separate self-sufficiency is not part of life there. A Christian on earth is just as much a part of the fellowship of saints as a believer now in heaven. And it is just as impossible for any earthly member of God's kingdom to exist on his own as it is for those gone on to heaven. The Christian is dependent, not only on Christ, his divine Head, but also on all the members of the family of God, the total body of Christ.

Our dilemma is that we resist dependence. To talk about it is simple. To know about it intellectually is relatively easy. But our understanding of it is fatally distorted, because we can perceive our dependence only from our human point of view.

Part of the redemptive process is an internal change of our ideas about dependence. And to change this most basic of our distortions is probably the last great objective of the valley period in Christ's dealings with any of us.

Peter and Dependence

The time had come for this to happen in Peter's life. Everything up to this time had been preparatory. Again and again he had experienced something of the diametric difference between what he knew of life and what the kingdom was really all about. He was now to experience, through a rapid sequence of events, what Christ had known all along: that left to himself and apart from God, Simon Peter, a strong rock, was nothing more than Simon—a weak, unstable pebble.

Jesus began by saying He was going where Peter couldn't follow. Peter couldn't understand. Wasn't he completely committed?

"Master, I'll die for You," he said.

"Don't be so sure, Peter. If you only knew it, instead of dying for Me, you will this very night deny three times that you even know Me."

Few things are more devastating than when a friend questions

your loyalty. And Peter was one of Jesus' three closest disciples. Not only could he not follow Jesus now, but his reiteration of total commitment had been rejected. He was beginning to experience an aloneness he had never felt before. Only those who have been through such aloneness can understand what was happening to him.

There are places and times when God will go beyond our depth, where we aren't able to follow. In this instance *no* man could follow Jesus. He had to tread the winepress alone. As Isaiah described it centuries before:

"I have trodden the wine trough alone, and from the peoples there was no man with Me" (Isa. 63:3).

The great sacrifice for man's sin could be made *only* by the Son of God. And in a way no mortal shall ever comprehend, our Saviour walked the "Way of Sorrows" alone.

> It was alone the Saviour prayed
> In dark Gethsemane;
> Alone He drained the bitter cup
> And suffered there for me.
>
> Alone upon the cross He hung
> That others He might save;
> Forsaken thus by God and man,
> Alone, His life He gave.
>
> Alone, alone, He bore it all alone;
> He gave Himself to save His own,
> He suffered, bled, and died
> Alone, Alone.
>
> Ben H. Price

We know that part of dedication is the freedom and right to follow. It is unnerving to be told there are places where dedication can't take us. But we need to learn to let God be God. This involves our willingness to remain in the dark, to be left outside, while He

gets on with His work, free from our demands for explanations.

Peter and Warfare

But there is another dimension to Peter's experience that is equally vital. The kingdom of God involves issues, forces, powers, and beings that remain largely hidden from man's understanding and experience. In the unseen but very real realm of eternity, there is an ongoing conflict—a fight to the finish. Satan and his hosts are locked in battle with the armies of the living God. While the final resolution of this conflict has never been in doubt, God has permitted it to continue through ages of time for reasons only dimly perceived by mankind. The little we can know suggests that God is using Satan and his hosts in mysterious ways to achieve God's ultimate purpose: to root out once and for all the remotest possibility that sin, once subdued in man's heart, shall ever again rear its ugly head. But until the crisis moment when Satan and his followers are given their final sentence, the conflict rages on.

"Simon—Satan has asked to have you, and he has been given permission to sift you as wheat. But I too have prayed, and God has put a limit on what Satan can do. I have prayed that, in the testing, your trust in Me won't fail."

Jesus was saying that the protection of God's grace and power would be partially removed for a time and that Simon would experience just how totally helpless man is without God.

To strike a deathblow to Simon's deep, innate self-sufficiency, God would use His archenemy who, in the beginning, had planted the germ of independence in the hearts of our first parents. What profound mystery—that the one who seduced our race and brought such misery and ruin to all mankind would be instrumental in its redemption!

But this is true only insofar as a person is related by living faith to Jesus Christ. Only when faith is real are the assaults of Satan, which God permits, in any sense redemptive. For it is through the experience of our absolute helplessness, and the complete inadequacy of our natural strengths, that we discover there is only *one* place of safety in life—the place of dependence—total trust.

Strangely, this place of safety is none other than that of blessed weakness—the helpless, trusting, childlike spirit. The assaults of Satan upon God's children are permitted only when God knows their impact will prove ultimately beneficial.

The decree had been given: "Go ahead, Satan." But the decree carried with it a clearly defined limit: "Don't annihilate Simon's trust." And that limit was secured by the intercession of the One who from the beginning purposed that Simon would in the fullest sense become Peter—a rock!

"Simon, you're going to be left alone, and yet not alone. I too have prayed. Although you'll come to the end of yourself, to the end of your wretched self-confidence, the final result will be glorious. Not only will your trust in Me not fail, but when you have gone through this sifting, you will be able to strengthen your fellow disciples in their trust."

Just as Jesus' intercession was effective and Simon's faith did not fail, so you and I can have the fullest confidence that even today Jesus Christ, seated on His Father's throne, will make effective intercession for us. When we are at the end of ourselves and our resources, buffeted and tested by the evil one, Christ is praying that we also will turn to Him as our only hope.

Dear heavenly Father,

I freely confess how little I understand the mystery of Your ways. To think that Satan becomes in Your hands an instrument for his own undoing and our ultimate good is more than I can fathom. But I take courage from knowing that Satan can touch me only by Your permission and under Your strict control.

Your dealings with Simon Peter elicit both fear and encouragement. I shrink from the thought that I too may have to go through deeper experiences of aloneness in order that my own sense of sufficiency may die. But I know You will be there—never letting me go. I know too that I can face each new day with the confidence that You have ordered its events for my good, and for my usefulness in Your kingdom, here and now.

In Jesus' name, Amen.

18
Don't Sleep Through the War!

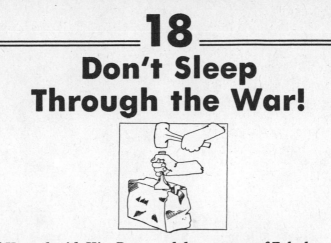

And He took with Him Peter and the two sons of Zebedee. . . . He said to them, "My soul is deeply grieved, to the point of death; remain here and keep watch with Me." And He went a little beyond them, and fell on His face and prayed. . . . And He came to the disciples and found them sleeping, and said to Peter, "So, you men could not keep watch with Me for one hour? . . . Are you still sleeping and taking your rest? . . . Arise, let us be going; behold, the one who betrays Me is at hand."

Matthew 26:37-46

The Passover supper was over. Judas was gone, but the disciples didn't know where. Jesus' lengthy talk and the prayer that followed left the men puzzled, yet strangely comforted. He had said so much that was mysterious and strange, like: "If I do not go away, the Helper shall not come to you; but if I go, I will send Him to you" (John 16:7). His Farewell Discourse and His High Priestly Prayer contain some of the most profound thoughts in all the Bible. (See John 14—17.)

One thing was clear to the disciples—there was trouble ahead. Just as they were leaving the Upper Room, Jesus asked them to be sure to bring swords. When someone noted they had two, He had said that would be enough.

The early morning was still dark when the little group arrived at the Garden of Gethsemane, a secluded olive grove where Jesus

often went to meditate and pray. Located across the Kidron Valley to the east of Jerusalem, it afforded both privacy and an inspiring view of the Holy City, with its skyline dominated by the golden splendor of Herod's temple.

The Supreme Struggle
But other thoughts filled Jesus' mind as He stopped in the darkness of the grove. His spirit was strangely troubled, and His voice revealed an inner struggle which was new and disquieting to His disciples.

He asked the group to stay where they were, while He went with Peter, James, and John just out of earshot. There He requested the three to stay while He proceeded a little farther and knelt on the ground to pour out His prayer to God, in agony of soul.

"Watch with Me, and pray," He had requested of the three. Instead they went to sleep!

"Peter, Wake Up!"
"Couldn't you watch in prayer for even one short period of time? There is temptation ahead, Peter. Watch and pray that you don't get snared in it. I know your spirit is willing, but your flesh is weak."

Jesus returned to His tryst in agony of spirit. As he struggled with unseen forces, He was becoming more aware of what was involved in being the sacrificial Lamb for a rebellious race. Sweat poured from His body until His clothes were drenched. His flesh cringed from what lay before Him and His spirit trembled, but He would not turn away from the Father's will.

Seeking relief from the pressure, and wanting strength from the fellowship of those He had asked to watch with Him, He went a second time to the three men, only to find them sleeping soundly.

This time He didn't waken them. He must fight the battle alone. And so, back to prayer He went. And there alone, on His face before His Father, He gained the victory. Peace came and His spirit was strengthened. He rose from prayer triumphant. From that moment until His last breath upon the cross, He was in total

control, the King yielding Himself freely and completely to everything God His Father would permit His archenemy to do.

What was the heart of the awful struggle through which Jesus went in the Garden? After all that has been written on the subject, the matter remains a mystery. Let it be this way: We will know in that day when we join with those above who even now know fully even as they are fully known (see 1 Cor. 13:12).

By yielding to death, Christ would conquer Satan and set mankind free. The grain of wheat, by dying, would rise again to a bountiful harvest. With the victory gained Jesus returned to His sleeping disciples.

"Do you now sleep on?" He said. "Is it time to take your rest? We are at war! See, My betrayer is coming. Get up and let's go!"

Spiritual Warfare

Even while He spoke the little group found themselves surrounded by a crowd of soldiers and officers from the temple guard. Rough, loud voices, flickering lights from lanterns and torches, and the hard metallic sound of clanking armor brought the drowsy disciples to their full senses.

The time for prayer was past. The time for action had come. And those who could only sleep during prayer were fully awake for war!

How little they knew what the issues really were! And their ideas of war were so diametrically opposite to those of their Master. He knew the real enemy was not the high priest and his crowd, nor the Pharisees, nor even the hated Romans. And He knew too that spiritual warfare is not fought as men fight wars. Centuries before the prophet had declared: " 'Not by might nor by power, but by My Spirit,' says the Lord of hosts" (Zech. 4:6).

And again: "The righteous will live by his faith" (Hab. 2:4).

It is God in the person of the Holy Spirit who at the appointed time brings judgment upon His enemies. It makes no difference whether those enemies are seen or unseen, whether they are men or armies of wicked spirits under the leadership of their master, Satan.

Man's part in all of this is to remain steadfast in his trust, and to act only as God may direct, while remaining constant in his faith. For it is God who does the fighting, not man.

Of the many issues fought out in Jesus' prayer in the Garden, a major one may well have been the reinforcing of Jesus' own implicit trust in His heavenly Father. We must not forget that Jesus lived His earthly life as a man. Every step He took, from the earliest moments of self-awareness to the last breath He drew, was taken in the spirit of quiet trust. All His actions, the waiting *and* the working, were done in the full confidence that each move was well-pleasing to God.

As Jesus came to the last moment of His life as a dependent man, He approached a double darkness—of physical death and spiritual aloneness. The most poignant cry ever to come from human lips was that spoken by the suffering Saviour, "My God, My God, why hast Thou forsaken Me?" While the billows of God's wrath rolled over the substitutionary Sacrifice, the Son of man responded to His own question by reaffirming His undeviating confidence in His Father God: " 'Father, into Thy hands I commit My spirit.' And having said this, He breathed His last" (Luke 23:46).

Never for an instant did He falter in His attitude of implicit, childlike trust in God. He led the way for us all by demonstrating that little-understood truth, "This is the victory that has overcome the world—our faith" (1 John 5:4).

But this kind of faith must be nurtured, strengthened, and renewed by communion with the Father. It was *faith in the Father* that was to carry Christ through to victory, just as doubting the Father had led our first parents and our race into ruin. In the Garden, alone on His knees, He fought the battle. The victory He won there was the victory of faith.

While the Master was girding on the shield of faith, Peter had been fast asleep, oblivious to the nature of the struggle ahead. Peter, secure in his total dedication, and with a trusty sword at his side, had laid himself wide open for the humiliating, soul-crushing defeat that waited so unsuspectingly near.

We are all much like Peter, so splendidly prepared for a battle

that will never come. We look to our training, our organization, our skills, our well-developed gifts, and our beautiful plans to do the work. But the crucial action takes place in the realm of spirit, not flesh. In this arena faith alone is effective. But faith must be alive, clear, and steady if it is to win the invisible battle. Possession of this kind of faith in the moment of crisis requires the agony of personal prayer struggle. Like Peter, how little we know of this deeper dimension of Christian warfare.

"Oh Peter, watch and pray, so you won't be overcome by temptation." And you and I need to watch and pray in our day, for the temptations will come, and in ways we don't expect. As with Peter, all the dedication and preparation in the world won't save us in that sudden moment when our trust is tested.

The battle is won, not by fighting harder, but by leaning steadier.

Dear Lord,

The spirit of prayer is so rare in our day. And I, like my brothers and sisters, find it easy to be alert to action, but sluggish and sleepy in the arena of prayer.

I take heart in the fact that You know and understand this deadly peril. If I do sleep, as Peter did, may my defeats teach me lessons of self-discovery I could learn no other way.

In Jesus' name, Amen.

19
What Is Your Complaint Against God?

While He was still speaking, behold, a multitude came, and the one called Judas, one of the Twelve, was preceding them; and he approached Jesus to kiss Him. Luke 22:47

Simon Peter therefore having a sword, drew it, and struck the high priest's slave, and cut off his right ear. . . . Jesus therefore said unto Peter, "Put up the sword into the sheath; the cup which the Father has given Me, shall I not drink it?"
John 18:10-11

It is difficult to imagine the incredible shock, consternation, and then hot anger which must have swept over the disciples when they saw Judas leading the band of soldiers. Betrayer!

Judas brashly stepped up to Jesus and with the kiss of greeting indicated to the soldiers the Man they wanted.

Like a flash the pieces fell together. This is what Jesus meant in the Upper Room when He said one of them would betray Him. Other incidents came to mind—the times when the common purse was empty and Judas, who handled the money, gave only vague explanations. But that Judas was a hypocrite and actually in league with Jesus' enemies hadn't dawned on them until this moment.

The Matter of an Ear
Galvanized into action, Peter whipped out his sword and swung at their enemies in bold self-defense. He barely missed killing a man

on the first swing, but did take his ear off. Suddenly Jesus spoke: "Put your sword away, Peter. This is My Father's cup. He has given it to Me. Shall I not drink it?"

What does He mean, His Father's cup? thought Peter. *How could this be from God? Are we supposed to stand by like helpless sheep and do nothing? Didn't He tell us to bring swords? "My Father's cup?" I don't get it.*

Peter was prepared to fight, and he would gladly have died defending his Master. But this—he couldn't understand. Reluctantly he replaced the sword and watched as Jesus stooped down, picked up the severed ear, and reattached it to the injured man's head. The disciples were sure now that God had not left His Son helpless. Jesus was surrendering to His enemies, not in helplessness, but with deliberate obedience to His heavenly Father.

Satan had entered into Judas, who had voluntarily yielded himself to the enemy. The religious leaders, filled with insane envy and cruel hatred, were likewise possessed by the evil one in implementing their decision to destroy Jesus. The crowd of soldiers and the ruffians accompanying them were hard men, to whom blood, suffering, and death were all part of a day's work.

Satan's crowd that night was callous of heart and totally worldly in outlook. Jesus had said He would drink from His Father's cup. Doing so meant temporarily submitting to the powers of Satan.

Man's Complaint Against God
The issues involved, as the drama of the ages unfolded that night, touch the very heart of that which makes God's kingdom eternal, all-victorious, and forever blessed.

Deep within man's heart, and often unrecognized, is a mortal hatred of the one eternal, holy, and ever-loving God. While the expressions of that hatred are infinitely varied, they can be summarized by distrust of God's character, rebellion against His authority, and cynicism toward His love.

At root some people believe God is wicked! They mean He is self-serving for demanding total submission to His authority, implicit trust in His veracity, and unquestioned acceptance of His

motives. They accuse Him of being capricious in His dealings, autocratic and tyrannical to the extreme in His relationships, monstrously cruel and heartless in His judgments, and hypocritical and insincere in His love.

They even charge Him with evil in extracting from His Son, whom He professed to love, the awful agony of Calvary just so He could be honored in extending mercy to poor helpless sinners. The calumnies of the human heart against the living God know no bounds.

Alone—one Man against a race—Jesus held true. For there in the Garden, with a confused disciple reluctantly sheathing his bloodstained sword, the Man of all men obeyed His Father in freely taking that cup of indescribable humiliation, agony, and death. He took that bitter cup in obedience that sprang from implicit trust, joyous submission, and adoring love. He took it because there is no other way possible for man the creature to relate rightly to his Creator, the eternally Self-existent One, who is totally good.

Jesus loved His Father for who He is in Himself—and the bitter cup the Father entrusted to His Son *was a cup of love*. In Jesus' free acceptance of that cup, Satan knew he had met his doom. The lie he had planted in man's heart in a beautiful Garden of Eden was unmasked in a nightmarish scene of confusion, hatred, blood, and evil in another Garden called Gethsemane.

Jesus' Obedience

The deathblow given that night to Satan and to all evil lay not in yielding passively to its outrage, but in yielding to it out of trusting, loving obedience to God. It was not Jesus' nonresistance that proved Satan's undoing, but rather His confidence in His heavenly Father.

During all of Jesus' earthly life, not one shadow of sin ever marred His soul. He was perfect in His filial relationship to His heavenly Father. He was righteous in His relationships with men and in all His dealings with them. He lived His life doing only what was right and good. And in the closing hours of His life on earth, as

He faced the fury of sin unleashed through devils and wicked men, He remained perfect toward God and man.

To be finally dealt with, sin had to be allowed to demonstrate its true nature, freely and fully. This necessitated an appropriate object and a favorable situation. The object had to be such as would draw forth the true character of sin, and the situation had to be sufficiently favorable to encourage sin to express itself without fear of immediate reprisal.

Both conditions were found in Jesus, the perfect Man standing as a helpless Lamb, in the presence of unrestrained evil. By choosing to accept in His own Person all that evil might do, He concurrently chose to leave the matter of vengeance in His Father's hands.

Evil was now free to do what it wished. It faced not the strong Lion of God, but the helpless Lamb. And sin was goaded toward its worst by the horrid spectacle of total goodness standing meekly before it.

Never before in history had such a situation presented itself— total hatred concentrating on goodness, in the person of Jesus. At long last, heaven, earth, and hell were seeing a demonstration of the real nature of sin. Nothing can be more corrupt, wicked, abominable, and hellish than to hate perfect goodness.

"Put your sword away, Peter. Don't hinder Me in the *real* conflict. This battle cannot be won unless I accept seeming defeat so that the enemy may be seen for what he really is—the would-be murderer of God!"

Dear heavenly Father,

How totally blind are my eyes and how unfeeling is my heart. So often my thoughts of You and Your love center wholly on what salvation means to *me*—escape from hell and an eternity of happiness. I have such slight awareness of who You really are. And seldom are my mind and heart gripped by the horror of my sin as You see it, in all its ghastly reality.

Set me free from a temporizing spirit that treats personal sin lightly, presuming upon Your grace and mistakenly assuming that

since Christ died for my sin, I am somehow free to continue living in it. May the judgment poured out on Christ at Calvary be reflected in my own conscience, fully agreeing that sin and I must forever be implacable enemies.

Enable me, O God, to hate sin as you hate it—not only as it exists in the world, but much more as I discover it in my own heart.

In Jesus' name, Amen.

20

I Don't Need You, Peter

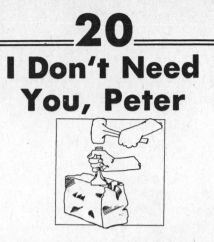

And behold, one of those who were with Jesus reached and drew out his sword, and struck the slave of the high priest, and cut off his ear. Then Jesus said to him, "Put your sword back into its place; for all those who take up the sword shall perish by the sword. Or do you think that I cannot appeal to My Father, and He will at once put at My disposal more than twelve legions of angels?"

Matthew 26:51-53

The scene and action haven't changed from our last chapter. Only Jesus' words are different. John told us of Jesus submitting to arrest as part of His Father's cup, which He willingly chose to drink. Matthew added another dimension to the scene, and the two records must be read together to see the total picture.

Just as Peter launched into a defense of his Master and was feeling the thrill of inflicting wounds on their enemies, Jesus ordered him to stop.

"Enough of that, Peter. We're in a different kind of war. Spiritual battles aren't fought with carnal weapons. You'll reap the same as you plant.

"Peter, man's wrath doesn't produce God's righteousness—it only produces more wrath. So put your sword away. Those who resort to its use in the end become the victims of their own weapons.

"Besides, Peter, I don't need your help in this conflict. If I wanted protection, My heavenly Father could send more than 12 legions of angelic soldiers. And He would do it instantly should I but ask Him. If I wanted protection, Peter, I could call soldiers more skilled than you."

But I Wanted to Help!

What is more devastating than to learn you aren't needed? Especially when you are ready to give everything you are or have to demonstrate your loyalty.

By this time Simon Peter was hopelessly out of his depth. Jesus had told him earlier that he wouldn't be able to follow his Master every step of His way. Peter's response had been to reaffirm vehemently his pledge of loyalty even to death. Now he was confused, and possibly resentful: *Jesus knew we brought swords, and now, at the crisis moment, He commands us to put them away.*

But what hurt most deeply was the implication that Jesus didn't need Peter's help. Jesus appeared totally defenseless before that crowd of soldiers. Yet He talked about legions of heavenly guardians. Wasn't He a Man who needed help?

Little did Peter realize how truly each of those fast-moving events was driving toward the final crisis moment when he, Peter the rock, would discover that by himself he was nothing more than Simon, the weak, vascillating, self-serving man he had been before Jesus Christ came into his life.

Hero at Work

Apart from divine illumination, every one of us is just like Peter there in the Garden. Not one of us would have understood what Jesus meant when He said, "The cup My Father hath given Me, shall I not drink it?" Each of us would have been equally puzzled and offended by Jesus' command to sheathe our swords, by His reminder that He had far better help than we could possibly give, in spite of our dogged determination to "fight to the death in the battles of the Lord."

What a blindness lies upon our eyes and our hearts. We read the

Scriptures but their true meaning so often eludes us. The issues of the kingdom of God are strange to us. Each of us needs to have our eyes opened and our hearts touched by a flame from above so that we can perceive and understand eternal reality.

Jesus was *not* standing there defenseless and helpless. But how could Peter know that? And to this day most people don't know it. The multiplied sermons dealing with the events leading up to Jesus' death nearly all depict Him as a victim of overpowering evil forces. The emphasis so often is on the injustices done to Him—the rascality of the covetous Judas, the cunning and teachery of wicked high priests, the fickle clamor of the masses who were incited to cry ''Crucify Him, Crucify Him.'' Much is said of the cowardice of Pilate, the brutality of the Romans, and finally of the totality of His aloneness as He hung between earth and heaven during those final agonizing hours.

In reality, He was walking through those moments of history in the most triumphant display time or eternity would ever be privileged to witness. By free and unreserved personal choice, Jesus was allowing devils—and men in league with them—to fully demonstrate what evil is really like. For this to happen, greater soldiers than Peter must sheathe their swords. The legions of God had to remain in their tents. None could come to His defense. He must tread the winepress alone. Evil must have its day so that all might see its true nature.

The Silence of God

There is yet another great issue in these events, which is impossible to perceive except by divine illumination: The character of God was at stake. His holy nature demanded that sin in His world be punished. But for the most part sin had run free in the earth, unchallenged and unchecked. Job had felt this when he insisted that the wicked often do not suffer but rather prosper.

The long millennia had rolled across an earth soaked in the gore of its own injustices, and a righteous God had kept silence. Would it always be thus? Would God forever shut His eyes to evil? Did He really mean it that day in the Garden when He warned our first

parents: "In the day you eat of the forbidden tree, you shall surely die"?

Have there not been times without number when it could have been said, "Right is on the scaffold and wrong is on the throne"? How many of the godly of earth have cried with the martyrs above, "How long, O Lord, holy and true, wilt Thou refrain from judging and avenging our blood on those who dwell on the earth?" (Rev. 6:10)

The silence of God does not mean indifference. He knows what He is doing. Before the worlds began, in those far-off eternal councils of the Godhead, it had been determined that He Himself would be the demonstration of what is meant by divine righteousness. It would happen at a point in time, "Now, once at the consummation He has been manifested to put away sin by the sacrifice of Himself" (Heb. 9:26). The universe would see on that day of days what a holy God must do to sin.

Not only was evil displaying its true nature as it wrought its worst on perfect good, but God was doing what He must do, as God, in visiting divine wrath upon sinful man. But contrary to all expectations in earth or hell, the demonstration of God's attitude toward a rebel race was not carried out by a stroke of vengeance on the rebels. Instead, He poured out the wrath on Himself, in the person of Jesus Christ, who by free willing choice had become the One "by whose stripes we should be healed."

"But the Lord was pleased to crush Him, putting Him to grief" (Isa. 53:10). "God was in Christ reconciling the world to Himself, not counting their trespasses against them" (2 Cor. 5:19).

God Is the Builder

The kingdom belongs to God, and He alone will build it. He uses people like Peter and like us, but we are useful to Him only as we let Him do the building in His way, at His pace, and by His power.

Before God can use us to help build His kingdom, we must become aware that God doesn't really need us. When we do not sense the reality of this, we tend to feel personal pride and self-

importance. And from there, it is but a short step to our becoming central to the work of the kingdom and God being only a servant.

Imagine yourself—you are gifted, trained, and dedicated to Christian service. In the crisis moment, when everything is about to collapse, you marshall all you are and have, and you throw yourself into the fray. You want to save the day for God.

How would you react when you heard the quiet but insistent voice of the Master:

"Sheathe your sword, My child. I don't need you to fight for Me. I have higher resources than anything you can muster. You see, it isn't by man's great abilities, determined dedication, or personal self-sacrifice that the work is done. It is rather by the pervasive power and influence of that Spirit, which is not of this world, that the kingdom of God is built.

"Yes, I will use you. But I don't need you. And to be useful to Me, you must learn to follow Me. I cannot use that spirit of drive and strife that really comes from beneath, that spirit which hurts, embitters, and engenders covetousness and vainglory. You must follow the Holy Spirit which is from above and who is first pure, then peaccable, gentle, easy to be entreated, full of mercy and good fruits."

Dear Lord,

How easily I get steamed up about my ideas of doing the work of Your kingdom. And how clumsily I thrash around, full of the heat of my own spirit, and expending a lot of energy, only to discover I've hurt instead of healed, destroyed instead of built, and hindered instead of helped.

Please keep reminding me that You dont need defending, that really You don't need my work at all.

I rejoice that You condescend to use people in Your work, and that You want to use me. Keep me from being carried away with my own zeal and earnest dedication. Enable me to see that the kingdom is built of different stuff than the world system which is so important to men.

I thank You, Lord, that a part of building Your kingdom is Your own building of me. Make me willing and pliable material, so that I myself may be built for Your glory.

In Jesus' name, Amen.

21
The
Crash!

Now Peter was sitting outside in the courtyard, and a certain servant-girl came to him, and said, "You too were with Jesus the Galilean." But he denied it before them all, saying, "I do not know what you are talking about."

And when he had gone out to the gateway, another servant-girl saw him, and said to those who were there, "This man was with Jesus of Nazareth."

And again he denied it with an oath, "I do not know the Man."

And a little later, the bystanders came up and said to Peter, "Surely you too are one of them; for the way you talk gives you away."

Then he began to curse and swear, "I do not know the Man!" And immediately a cock crowed.

And Peter remembered the word which Jesus had said, "Before a cock crows, you will deny Me three times." And he went out and wept bitterly.

Matthew 26:69-75

It had been a wild, tension-filled night after a long grueling day. Now, as the early predawn chill penetrated every part of his weary body, Peter was glad for the fire some soldiers had kindled in the palace courtyard. He crept closer, anxious for any warmth that would quiet his shivering body, yet fearful lest the light of the fire

would betray him to the group of soldiers who had just brought the captive Jesus to the palace of Caiaphas, the high priest.

Calmed a little by the warmth of the fire, Peter tried to sort out the bewildering rush of events that had left him almost totally unstrung. Just a few hours before, as the disciples had gathered in the Upper Room to celebrate the Passover meal with their Master, he had felt completely adequate. In spite of a few strange and ominous signs of an impending crisis, Peter had been ready for anything. One thing was certain, whatever might happen, Jesus could count on him.

As he had sat with the other disciples around the table, Peter had realized that a lot depended on him. *On whom could Jesus really count in a crisis? Surely not mystical John or doubting Thomas. And Judas was such a loner. No,* Peter had thought, *in the crunch he would need to take over and try his best to lead the little band in an all-out defense of their Master, should He become in any way endangered.*

After all, the crowds were for Jesus. Hadn't they publicly acclaimed Him a few days before? If only the inner circle of disciples would lead in a determined defense, the crowd would surely rally to their Champion, and soon the enemies of Christ would be overcome and a new day would begin.

Before the Dawn

Now all was changed. Events had moved so swiftly. Nothing had worked out. It seemed as though Jesus *wanted* to be captured. Certainly He had done nothing to avoid it. But the most bitter part of the whole confused night was the awful rejection Peter felt when Jesus commanded him to put away his sword. That had really hurt, and added a dimension of resentment to Peter's confusion.

Was everything completely lost? Judas was finished. And the rest of the disciples had fled the moment Jesus gave that strange command to His captors, "If you seek Me, let these go." True, John hadn't run with them, but what could two of them do now that Jesus was chained and the enemy obviously had the upper hand?

The barest hint of dawn could be seen in the east. Faces around

the fire were slightly more distinguishable. Would he be recognized as a member of Jesus' group?

Suddenly a servant-maid came up to him and, pointing her finger at him, almost shouted, "I've seen you with that Galilean they've just taken prisoner."

"What are you talking about?" replied Peter. "I've never met the Man."

Attracting as little attention as possible Peter moved away from the group to the deeper darkness of the porch. Suddenly another servant-girl saw him and boldly said to those around her, "Hey! There's one of the group. I've seen him with Jesus."

Peter cursed. Panic began to grip him. "You're a liar. I don't know any Jesus."

Things quieted down. The soldiers stirred the fire. Peter huddled alone with his pounding heart and distracted thoughts, when suddenly someone came up to Peter:

"You've *got* to be one of His crowd. We can tell by your speech you're from Galilee, and that Man they've captured is a Galilean. You aren't fooling anyone."

Peter's mind went blank as panic took over. With oaths and curses he swore he had no acquaintance with the Prisoner. Everything in him wanted to run, to hide, to get away from the whole cursed mess.

A rooster crowed in the early dawn. And Jesus, standing chained just inside the portico, turned to look at Peter.

As blinding tears coursed down his cheeks, Simon Peter slipped through the gate of the palace courtyard and ran. Finding a place where he could hide, he gave himself up to the bitter, scalding tears of shame, humiliation, defeat, and despair.

Peter had come to the end of himself. His life had turned to ashes. He was totally empty. He was a failure, a sinner—equal in guilt and shame with Judas. How long Peter wept we don't know.

At Dawn

The crash must come for us all, for me, for you. For we are totally blind to our real selves. At the root of our nature is an irremediable

principle of self-love. It stays well hidden in the darkness of the heart, but is ready at any moment to assert itself whenever the self is really threatened. There is only one way self-love can be handled—by death!

This is the purpose of the valley period for the person whom God intends to make useful in His kingdom. We need to know in actual experience the meaning of those words of the Apostle Paul, "For I know that nothing good dwells in me, that is, in my flesh" (Rom. 7:18). It is easy to learn this doctrinally, and I am sure Peter knew very well the Old Testament expression of the same truth: "The heart is more deceitful than all else and is desperately sick; who can understand it?" (Jer. 17:9)

But the knowledge of the truth did not keep Peter from yielding to self-love when his self-preservation was threatened.

Like Peter, we have surrendered to Christ, trusted and obeyed Him, and have even seen answers to prayer and faith. When questions have arisen regarding our relationship to Him or our loyalty to Him and His cause, we too may have declared with vehemence that we can be counted on.

But earnest declarations of loyalty are not enough. Promises, vows, surrenders, and dedications will not in themselves assure loyalty to Christ when the pressure is on and the self is threatened. There must be a personal experience of doctrines believed. You and I have to learn *through experience* that we dare not count on our good resolutions to hold us true in the hour of trial.

However, the process by which we learn Peter's lesson must be engineered by God, not man. Only He knows how and when to arrange life's circumstances in such a way that the desired results may be achieved. Jesus had told Peter that God was going to let him experience profound sifting, and that Satan would be God's instrument for this. The trial came in God's time, by God's design, and Satan had access to Peter's life *only* by God's permission.

Our job is to be aware as best we can of what needs to be done in us, and then trust God to arrange life for us as He chooses, believing that He will lead us into the trial—and through it, in His own time and way.

The Doorway to Day

For Peter the crash had come. He now realized that he was not a bit better than the weakest disciple. His pride was shattered, his self-confidence broken. His life had turned to ashes.

Only two paths were open to him—the blackness of complete despair, or the way of penetential trust. Judas took the former and ended in eternal midnight. Peter took the latter and discovered the doorway to eternal day. For at the end of his road, in the heap of the ashes of life, near the grave into which his self had fallen, Peter's faith found God!

This is why it is so imperative that we let God take us through the Valley. For only at the end, when we have learned there's nothing in ourselves to trust, can we discover the real meaning of trust. Only at that point can we experience reality in the depths of our being.

That bitter breakup of Peter's inner self was the beginning of life in a totally new dimension. Jesus had said, "Unless a grain of wheat falls into the earth and dies, it remains by itself alone; but if it dies, it bears much fruit" (John 12:24).

Paul testified, "I have been crucified with Christ; and it is no longer I who live, but Christ lives in me; and the life which I now live in the flesh I live by faith in the Son of God, who loved me, and delivered Himself up for me" (Gal. 2:20).

The Christian religion is the *only* religion in all the world that makes human insufficiency the gateway to blessing.

Dear heavenly Father,

I rejoice in the fact that You will complete in me what You began when I first trusted You. You will not spare my hidden self-love, but in Your time and way will bring whatever deaths may be needed so that my trust may be totally in You and not in myself. I thank You for praying for me as You did for Peter, that I too will hold steady.

In Jesus' name, Amen.

Fulfillment

22

Fulfillment Comes After Failure

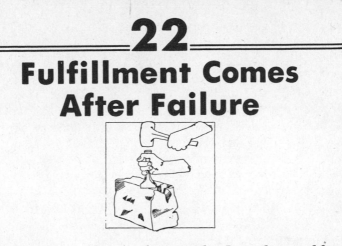

They arose that very hour and returned to Jerusalem, and found gathered together the eleven and those who were with them, saying, "The Lord has really risen, and has appeared to Simon." *Luke 24:33-34*

For I delivered to you as of first importance what I also received, that Christ died for our sins according to the Scriptures, and that He was buried, and that He was raised on the third day according to the Scriptures; and that He appeared to Cephas, then to the Twelve.

 1 Corinthians 15:3-5

Who can measure the depths into which Peter's spirit sank during those dreary hours and days while Jesus' body lay silent in a sealed tomb? We are given no details in the account, but our thoughts about that dark period can be guided by our understanding of human nature. There must have been repeated floods of bitter tears as humiliation and shame swept over the broken disciple again and again. The Scriptures make it clear that the disciples did *not* expect Christ to rise from the dead, and so Peter could not have been sustained by hope from that direction.

Introspection

There must also have been hours of intense reflection. So much that Jesus had said during their years together was mysterious. And

113

the experiences of the past months had left Peter increasingly less sure of himself. But the more unsure he became, the stronger were his declarations of loyalty. And now—all was finished!

Those early days of excitement, daring faith, and wonderful heavenly response seemed like a vague distant dream. Jesus had even called him a rock. He had made profound and soul-stirring statements about Peter's future.

Did it begin that awful day when Jesus had told him, "Get thee behind Me, Satan"? Peter had meant well. He simply couldn't imagine Jesus being killed when He had stated clearly that He would use Peter in building an impregnable church. Yet, just as Jesus predicted, the religious leaders had done their awful work, and He was dead!

Like morbid procession, one incident after another came across Peter's mind. Each one, it now seemed, had stripped from him just a little more of the self-assurance that had risen to such heights in the earlier days of spiritual glow and success.

And these last horrible days! Peter dared not reflect on them. How could he ever hold his head up again? Did God still love him? Surely no sin could be deeper than actually swearing with oaths that he had never met his Master. Even Judas' sin seemed small in comparison. At least Judas hadn't boasted of his loyalty. Nor had Jesus ever included him in the small, intimate circle.

The valley period had done its work. Through the bitterness of total personal failure, Peter had discovered there was nothing in himself to trust. Like so many before him, he had learned that his best, even when dedicated to God, was no better than a broken reed, which if leaned upon would only pierce his hand and leave him defenseless and wounded.

Insufficiency

Before any person can be really useful in God's hand, he must learn that *all* his resources are contained in that limitless and never-failing Source—God. Personal inadequacies and weaknesses are liabilities only to the degree that they are counted on as your resource. But if your resource is outside of yourself in the

limitless, eternal, the never-failing God, and if your relationship to Him is secure, then you need not fear your own insufficiency.

Living the Christian life and serving a holy God demand continuous supplies of supernatural dynamic. But unless you stop counting on your personal adequacy, you will draw upon those heavenly resources only sporadically, and with reluctance.

If you believe you are sufficient, it is painful to acknowledge dependence on someone else. You don't want another coming to your rescue to remind you that you aren't adequate. And yet every situation that is too much for you will deepen your fears, lower your sense of self-worth, and increase the temptation to hide what you fear to be the real you behind a facade of pretense.

The kingdom of God could *never* be built on such an unpredictable and insecure foundation. Jesus' statement that He *would* build an impregnable church could be made because He knew it would be built on the unshakable foundation of the total adequacy of Omnipotence. God could and would use people in the building process, because through redemption they would have learned to trust not in themselves, but in God alone as their Source.

The valley period establishes the foundation for this freedom from self-dependence. As you see in actual life that you don't have what it takes, you begin to understand that you *must* count on God alone for whatever you need to live and serve acceptably.

Daybreak

What seemed to Peter to be disaster was in reality but the midnight preceding the dawn, the ending of winter before glorious springtime, the grain of wheat dying in order to rise again to bear a harvest. How little we realize that inner personal bankruptcy, when opened to redeeming grace, is actually the doorway into life with God. Praise God, Simon Peter was finished!

"Peter . . ."

"Yes, Lord . . ."

The Scriptures are strangely silent about that first meeting between the risen Lord and His broken disciple. We know only that they met privately.

"The Lord is risen indeed and hath appeared unto Simon."
"Christ . . . hath been raised on the third day . . . and He appeared to Cephas; then to the Twelve."

We don't know the time, the place, or the circumstances. We don't know a word of what was spoken. And where the sacred record is silent, wisdom and reverence agree with the silence.

We do know that the One who prayed before the trial that His disciple's faith would not fail, did not forget that one who was so sorely broken in the trial. We need to learn that we can trust our faith to Him who is its Author as well as its Perfector.

Fulfillment

Yes, Jesus sought Peter out. He found him, and in that finding, Peter knew his Lord was not dead but living.

Following the valley is fulfillment. And the fulfillment begins, not with mighty deeds, but with the soul-quickening awareness that at the end of our road, God is. When God is there, we need nothing more, for He is enough.

Moses' dreams were shattered. A fugitive in a foreign land, he spent 40 monotonous years herding sheep for Jethro, his father-in-law. He had once started to deliver his people from their enslavement to Egyptian bondage. His natural abilities and his superb training surely fitted him for that crucial hour. Didn't everything point to the obvious, that God had brought him to the kingdom for such a time? But he had hardly begun to fight for his people when everything blew up in his face. Moses, the rising star on the Egyptian national scene, became a broken, disillusioned fugitive, afraid for his very life.

For him the valley was long and tedious. It seemed God had forgotten and prayers went unheeded. There was no sign of God fulfilling His word spoken centuries before to Abraham.

One day Moses saw a desert shrub on fire, yet the shrub wasn't burned. A Voice spoke from the fire—Moses was face to face with God! The vision which seemed shattered 40 years before suddenly came to life in God's words of command, "Go and tell Pharaoh, 'Let My people go.' "

Varied in detail, but the same principle, what was true for Simon Peter and for Moses, has been true for countless numbers of God's servants through the ages. Fulfillment of God-given vision begins in actuality after the dark night of valley. And it begins by a new and spirit-reviving awareness that the living God is here, personally present, with the broken servant who has found that alone he is nothing.

"Simon—it is I, Jesus—risen from the dead and Lord forever."

Simon answered, "Yes, Lord!"

And through his tears his heart surely leaped as he worshiped.

Dear God,

How unsearchable are Your judgments and Your ways past finding out. Who but God could have conceived such a complete and available redemption for a rebel race? Who but God would use the ruins of our depravity to create an eternal kingdom of perfect righteousness and total love? Who but God would open His kingdom to babes, to the weak, the poor—to all who are willing for You to be Lord?

Dear Lord, I worship You, my Life and my All. It is enough to know You are both alive and present with me. I ask You to fulfill Your will for me and Your purposes through me.

In Jesus' name, Amen.

23
Shepherd My Sheep

So when they had finished breakfast, Jesus said to Simon Peter, "Simon, son of John, do you love Me more than these?" He said to Him, "Yes, Lord; You know that I love You." He said unto him, "Tend My lambs."

He said to him again a second time, "Simon, son of John, do you love Me?" He said to Him, "Yes, Lord; You know that I love You." He said to him, "Shepherd My sheep."

He said to him the third time, "Simon, son of John, do you love Me?" Peter was grieved because He said to him the third time, "Do you love Me?" And he said to Him, "Lord, You know all things; You know that I love You." Jesus said to him, "Tend my sheep."

John 21:15-17

The beauty of the period of fulfillment is the high degree to which God and His work are prominent. The human element, while present, is subordinate. The person God uses is active, but the power is God's. Soul-destructive tension is absent. The intolerable pressures created by our human drive to achieve are replaced by an awareness that God, the Omnipotent, is doing the work, carrying the burdens, and causing the whole picture to stay in focus. Instead of frenzied pushing, man's part is to trust, keep his relationship with God clear, and respond to divine directives as they are given by God.

First Love—Fishing

Peter's first love was fishing. It was in his bones, a part of his life. But the vision God had given nearly three years earlier was of a life taken up with something much greater than gathering the daily supply of food from the depths of the Sea of Tiberias.

We subconsciously gravitate toward that which we love. A part of God's work in fulfilling the vision He gives us is to impart a deep and growing love for that of which the vision speaks. But He does it freely, naturally, and completely.

God had not forgotten His word to Simon the fisherman, given on that memorable day so long before. It had happened after a wearying and fruitless night of casting nets that Jesus had directed the disciples to a miraculous catch. And there, in the presence of two boats loaded with fish, Simon had heard those thrilling words. "Follow Me, and I will make you a fisher of men."

Three years later the scene was replayed. This time it was Peter the disciple who had returned to his old trade. For more than a month after the blackness of Jesus' death, not much happened. The disciples knew Jesus was alive, but He was no longer with them in the same way as before. He would suddenly appear and as quickly be gone, but they knew not where. As to a program for action, there seemed to be none. In a very real sense everything was in limbo. The disciples were leaderless, and what they had thought was a movement of reformation in Israel had totally collapsed.

Peter still felt keenly the implications of his own miserable denial. Although he knew Jesus loved him, and that through Christ's forgiveness the awful guilt of his sin had been removed, Peter had no confidence that he should or could take any prominent role in rallying the disciples to a pursuit of a program in keeping with the teaching they had received during their years at Jesus' feet. Not only would Peter not have known how to implement such a program if he could produce it, but he also had no confidence in himself. Furthermore, he was certain the other disciples had lost all confidence in him, and with good reason.

Strange as it may seem to us, throughout three or more years of training His disciples, Jesus had never spoken a word about *how*

His program should be carried out. He spoke of building His church, but He left no directions. He talked about the Gospel being preached in all the world, but He made no reference to the kind of organization or program through which this would be done. The disciples were completely in the dark about what they should do next.

In the fulfillment of vision, we not only trust God as adequate for all we need personally, but we also rest in assurance that He is adequate for fullfilling the vision itself.

In the absence of divine directives and in the light of all that had happened, Peter did what was perfectly normal and right—he followed his heart and went back to his old vocation. But the effort proved fruitless and frustrating. Like that time three years before, he fished all night and caught nothing. God has His way of preparing us for understanding His will. Sometimes He does it by withholding success. It isn't very satisfying to toil all night and have nothing but empty nets to show for our work—even if we do love fishing. In such a free, spontaneous, and unforced way God prepared Peter for the second step in effecting fulfillment of the vision Christ had originally given him.

The events were almost identical to the scene three years earlier. With a simple command and a response of obedience, failure turned into success. The boat was full of fish, and yet Peter was far more aware of Jesus as He stood on the shore. He was inviting Peter and the disciples with him to partake of a miracle breakfast, cooked and ready for the hungry men.

They ate in silence—each man alone with his thoughts. As the breakfast ended, Jesus broke the silence.

First Love—Jesus

"Simon, son of John, do you love Me more than these?" Jesus asked. The question came so unexpectedly and pierced so deeply. There was no reprimand for past failures or sins. He wasn't scolding because Peter had initiated the idea of returning to his old vocation. He was simply asking, "Where is your heart?"

"Yes, Lord. You know I love You," Peter replied.

"Then feed My lambs," commanded Jesus.

"Simon, son of John, do you love Me?" The shaft went deeper this time, nearer to the core of Peter's heart. He couldn't help cringing at the remembrance of a different early morning fire, two servant-maids, and the vehemence with which he had blurted out his denials that he had ever known Jesus. Nearly in tears and from deep within came his answer, exactly as before:

"Yes, Lord, You know I love You."

"Then take care of My sheep," replied Jesus. (See John 21:15-16.)

"Simon, son of John, do you love Me?" This time the arrow pierced into the very center of Peter's soul. Didn't Jesus believe him? But then, why should He? Hadn't he cursed and sworn three times in succession that he'd never even met Jesus? And yet, in spite of those awful denials, deep within himself, Peter knew he loved his Master.

He also knew that Jesus understood his heart perfectly. Nothing could be hidden from Him. Yet, strangely, the knowledge that he was known so fully no longer frightened Peter. Rather, it gave him a deep inner assurance and peace. At long last he didn't have to trust his own confession. Gone were his defenses, his vehement declarations of loyalty.

No longer did he need to bolster his own ego, or try to convince others that he could be counted on, no matter what others might do. His security was built on a deeper foundation—on the fact that Jesus Christ knew him perfectly. And He who knows all things, to whom every secret is open, knew full well that Peter loved Him.

Peter's replies to Christ's probing questions were simple. He didn't argue or defend, but replied as a man who had nothing to prove, who had come to the end of himself and was now content to be whatever he really was and no more.

The Scriptures give us Peter's reply so simply and clearly. He was grieved because Jesus asked him the third time, "Do you love Me?" And with deep emotion, Peter replied,

"Lord, You know all things; You know that I love You."

Christ's reply was again a command, "Feed My sheep" (21:17, NIV).

Jesus did not question Peter's love. He only probed until He knew that *Peter* was sure of his love. Then, based on the fact that Christ knew Peter loved Him, Jesus publicly reiterated His commission to Peter. Christ, by this public probing of Peter, and the three-fold commission given him in response to the probing, publicly affirmed His confidence in Peter. In this way, He reinstated Peter to a leadership role among the disciples.

When God puts one of His servants in a position of leadership, He Himself establishes that one in his position. Peter didn't have to prove himself to the other disciples, nor do we need to fight for position, or vindicate ourselves before others. God does that for us, adequately and effectively.

This commissioning was followed by the simple directive, "Follow Me" (21:19). The fulfilling of the command to shepherd Christ's sheep and His lambs was to be accomplished by following Jesus, his risen Lord. If Peter had wanted an outline of procedure, a plan of action, a program to implement, he was disappointed by Christ's directive.

There is only one requirement for successful fulfillment of God-given vision—"Follow Me." It is God who does the work. He Himself is our entire resource for doing His will. The primary requirement is for us to keep our hearts related to Him, our ears open for His directives, and our wills responsive when He makes His purposes known.

The elaborate organization, strategy planning, and program pushing that dominate Christian service today seem so foreign to the kind of leadership we see in Scripture. Moses was given little advance instruction as to the strategy he was to follow in liberating his people. His task was to keep his heart, ears, and mind open to God's voice. As he returned to Egypt to do what he had tried and failed to achieve 40 years before, God went with him, giving him his orders step by step.

The same was true in building the early church. The one essen-

tial command was a simple "Follow Me." As Christians did that, the great enterprise expanded in glorious fulfillment step by step. Central to it all was the awareness that One greater than man was doing the work. People couldn't help but see that the total work, from beginning to end, was of God.

Dear Lord,
 Because You know all things, You know that I love You. Teach me to rest in the wonder of Your perfect knowledge of my heart, for it is in the certainty that You know me completely that I find freedom to follow You and do Your will.
 I worship You for the completeness of Your great redemption. When You are my all, I need not try to prove myself or become someone other than what You are making me. As I seek to faithfully follow, You will enable me to accomplish all of Your will for me.
 In Jesus' name, Amen.

24
You Can Know
for Certain

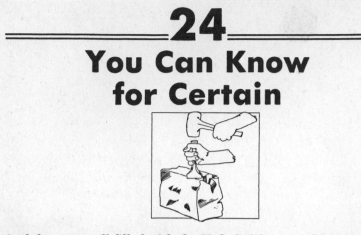

And they were all filled with the Holy Spirit. . . . Peter, taking his stand with the eleven, raised his voice and declared to them. ". . . Let all the house of Israel know for certain that God has made Him both Lord and Christ—this Jesus whom you crucified. . . ." Those who had received his word were baptized; and there were added that day about three thousand souls.

Acts 2:4, 14, 36, 41

God was in Jerusalem on the Day of Pentecost. And before the day was over, the people knew it. But at the center of what was happening was God's man—Peter, the rock. The man God had formed was doing God's work in God's way and in God's time.

As Peter stood facing the motley throng, some people were perplexed and some mocked. All were astounded as each man heard in his native language a recital of the wonderful works of God.

The Holy Spirit had suddenly appeared on the human scene to take up the work Jesus had begun before His death, resurrection, and ascension. Now, instead of living and working as a Person outside of the disciples, as Jesus had done, God took up His abode within them. He was the unseen but intensely real "Dynamic of God" clothed in the flesh and personality of each disciple. Through the Holy Spirit's presence and power the disciples were motivated, directed, and enabled to begin the impossible task of

building the church, a task which has continued through the centuries and into every part of the globe.

Transition

What a change had come over these men! Only a few weeks before they had been hopelessly discouraged, and dominated by two paralyzing realities, the death of their Master and the cutting cruelty of their own total inadequacy. Added to these fearsome negatives was the overpowering burden of personal guilt for their cowardly abandonment of Jesus at the crisis moment of His capture.

Even His resurrection had not cleared the air completely. While the burden of guilt lifted, and the gloom over His death changed to joy, the future was still cloudy. What about the kingdom? Would Christ never spell out His strategy? In meetings after the Resurrection, He spoke of matters related to the kingdom, but always in general terms.

One day they pressed the question, "Lord, is it now that You will restore to Israel the glory she once knew as a proud nation?" (See Acts 1:6.)

His answer was not clear. He seemed to sidestep the issue by referring the time factor to His heavenly Father. Then He spoke to them of an experience of power that was to be theirs in the near future. As a result they would become His witnesses worldwide.

Transformation

Now it had happened! And standing fearless before the throng, the man who had been intimidated by a little servant-maid a few weeks earlier was boldly charging the crowds with their horrible sin of murdering the Prince of life. He and the other disciples seemed to know instinctively what to say and what to do. They were possessed with a courage totally new to them and guided by a wisdom they had not formerly known. As Peter poured forth the burning burden of his heart, in simple yet compelling words, the multitudes were smitten with conviction. They suddenly saw themselves as guilty before God and justly deserving His holy wrath. Hearing

their cry for mercy and observing the reality of their repentance, Peter declared to them the message of hope.

"Repent, and let each of you be baptized in the name of Jesus Christ for the forgiveness of your sins; and you shall receive the gift of the Holy Spirit. For the promise is for you and your children, and for all who are far off, as many as the Lord our God shall call to Himself" (Acts 2:38-39).

The response was immediate and overwhelming, as 3,000 people turned to Christ that day, and through public baptism identified themselves with the crucified and risen Jesus Christ of Nazareth.

The actual work of building the kingdom had begun. The vision which had been so dimly perceived, and so vaguely outlined, now burned clearly and vividly in each disciple's heart. Gone was the grief over Christ's ascension to heaven, with the awful sense of void it had left. Instead they knew He was now with them more intimately than He had ever been before. For the first time since meeting Jesus over three years earlier, Peter and the others knew the secret of the incredible life Jesus Himself had lived while on earth. He had expressed it on various occasions during His earthly ministry, but they had never understood what He was talking about. His words, "I and the Father are One" had left them puzzled. Then one day He had promised the same oneness to them, "In that day you shall know that I am in My Father, and you in Me, and I in you" (John 14:20).

Now they *knew!* Through the indwelling of the Holy Spirit they *knew* that the risen, ascended Jesus lived within each of them.

They *knew* by His indwelling that they were one with the Father and the Son—as *one* as is the head and the body, the vine and the branches.

And with the awareness of that oneness with God, their hearts and minds were at rest. The Bible became an open Book, the path they were to follow became clear, and the perplexities with which they had struggled for so long could now be left in the Father's hands.

With this indwelling as an experiential reality, they knew Christ as their wisdom, righteousness, sanctification, and redemption.

No longer did they have to struggle. Freed from striving to become, they were now free to get on with doing God's will. As they did it step by step, moment by moment, they witnessed in amazement the building of the church. In the process of its development they found themselves building according to a heavenly blueprint.

Trust

Fulfillment for you and me may not be as dramatic or vivid as it was for Peter and the other disciples. But it must be the same in principle.

The underlying reality for every person who has been through the valley and in whom fulfillment of vision is being realized is expressed by Paul: "I have been crucified with Christ; and it is no longer I who live, but Christ lives in me; and the life which I now live in the flesh I live by faith in the Son of God, who loved me, and delivered Himself up for me" (Gal. 2:20).

The truth expressed in this passage must be more than a doctrine believed. It must be a Spirit-wrought awareness within the soul. At Pentecost the disciples *knew* Christ had come to dwell within them in the person of the Holy Spirit. This was not something that became true because they believed it. They believed it because it was already true.

As certainly as any individual comes to the end of himself and of his own resources, and in faith asks the risen Saviour to be his all, Christ will in some way make Himself known as the Indwelling One. It is at this point that struggle and striving cease, and those mysterious words in Hebrews 4:3 and 10 are fulfilled: "For we who have believed enter that rest. . . . For the one who has entered His rest has himself also rested from his works, as God did from His."

From this point on there are two concerns which should occupy us:

• We are to hold steady in our confidence in Christ as our all.
• We are to obey implicitly as soon as His will is known in any situation.

The directive given to Peter, "Follow Me," comes to us as well.

The paths we will walk will vary as much as individuals and circumstances vary. But our personal lives should be marked by the intangible but very real presence and influence of the living, risen, holy Son of God.

As we grow and mature in that life of trust and obedience, we will be known increasingly as those whose hearts are in another world. And people will see in us the reality, the value, and the beauty of Christ's eternal kingdom.

Dear heavenly Father,

I thank You for the profound simplicity of Your will and Your ways. Lead me steadily on that simple path of implicit trust in You and cheerful obedience to Your will.

Thank You, Lord, that the beginnings of the church were not the result of great organization, huge budgets, frustrating pressures, or vivid personalities. I worship You, and take courage that those beginnings were marked by the miracle of Your presence enshrined in very ordinary mortals, so that "the exceeding greatness of the power might be of God and not from man."

Lead me and all of Thy great family back to the simplicity, spontaneity, power, and love of Pentecost. Revive among us the deep God-wrought awareness that Christ within, and Christ alone, is our only hope of glory.

In Jesus' name, Amen.

25
It Will Cost You Yourself

"For My thoughts are not your thoughts, neither are your ways My ways," declares the Lord. "For as the heavens are higher than the earth, so are My ways higher than your ways, and My thoughts than your thoughts."

Isaiah 55:8-9

For consider your call, brethren, that there were not many wise according to the flesh, not many mighty, not many noble; but God has chosen the foolish things of the world to shame the wise, and God has chosen the weak things of the world . . . and the base things . . . and the despised, God has chosen the things that are not . . . that no man should boast before God.

1 Corinthians 1:26-29

Nothing in all the annals of human wisdom has even approximated the amazing mystery and profound simplicity of God's utterly unique plan of redemption. It is not enough to describe it in words. We need to see it portrayed in the living experience of those who partake of God's redeeming love and power. As we read the biblical description on the one hand, and study its application to flesh and blood reality on the other, we will find ourselves somewhere along the way.

None of us will go through precisely what Simon Peter or the other disciples experienced. In that sense we cannot follow them. But each of us must go through *in principle* what they did.

Peter's Path

In the preceding chapters we have followed Simon Peter through his varied experiences with Jesus Christ. We heard the first diagnostic word that Jesus spoke, "You are," and the glorious word of promise, "You shall be." We walked with Peter as vision unfolded and became like heady wine to an eager imbiber.

From the pinnacle of glorious vision we followed through the long and winding valley that ended in the dark night of Peter's soul. We saw him stripped of everything in which he had trusted, and left hopelessly inadequate, completely self-seeking, and totally bankrupt. We heard him weeping bitterly, in miserable, guilty, self-reproaching failure. The man of vision, stripped of everything and at the end of himself, discovered the meaning of those words, "I know that nothing good dwells in me, that is, in my flesh" (Rom. 7:18).

Out of the ashes of Peter's death to self we saw the wondrous new life of redeeming power and love, a resurrection into glorious union with his risen and ascended Lord. Now Simon, united to Jesus Christ by the Spirit's indwelling, became Peter, the rock. And as a man re-created by God Himself, Peter was the one through whom God laid the foundations of that mighty building, the church. That work has gone to the ends of the earth and continues to this very hour.

Your Path

But it is not enough to walk that long and winding path with Christ's disciple. You need to *find yourself* as you walk. There is a danger that you may be caught up in the wonder, or weep at the heartache, or be carried away by the sheer splendor of a triumphant climax. You can read, meditate, and be enthralled—and remain neither better nor worse for the exercise.

Go back over the pilgrimage—chapter by chapter. Do you understand the *divine dynamic* set forth in each? Describe in your own words what that dynamic is. Do you see that Simon Peter experienced *eternal principles* that you too must experience, although in different form and detail? Don't worry about the order

of the experiences, and don't try to find out *where* in the pilgrimage you may be at the moment.

Rather, ask what God is getting at right now. Ask what it will cost you to be honest with yourself and with God.

List the things you must do if you are to obey Him right where you are at this moment in your life.

Most of all, will you *expect Him to do everything in you and through you* that He has promised or ever may promise? You may, on this *one* condition—"Follow Me!"

Lift your heart to Him right now, and in simple words *tell Him* you do expect Him to make you what He has promised you shall become.

Dear Lord,

Grant each of us vision from You, for, "Where there is no vision, the people perish."

Take us through the valley, to the end of self-trust, and to the threshhold of true God-confidence.

We praise You, that for every one who will follow the vision You give, and who will walk with You through the valley, there will be fulfillment. Thank You, dear Lord, that wherever we are, You are able and faithful to make us what Your will declares we shall be.

In Jesus' name, Amen.

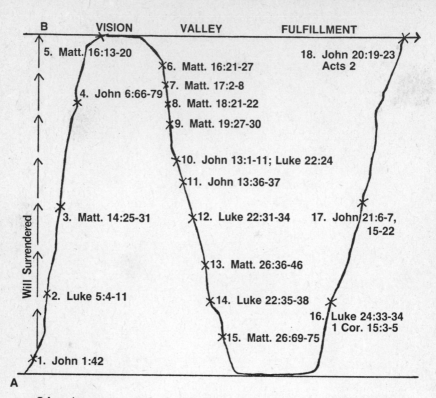

B　　　　VISION　　　　VALLEY　　　　FULFILLMENT

5. Matt. 16:13-20

18. John 20:19-23
Acts 2

6. Matt. 16:21-27

7. Matt. 17:2-8

4. John 6:66-79

8. Matt. 18:21-22

9. Matt. 19:27-30

10. John 13:1-11; Luke 22:24

11. John 13:36-37

3. Matt. 14:25-31

12. Luke 22:31-34

17. John 21:6-7, 15-22

13. Matt. 26:36-46

2. Luke 5:4-11

14. Luke 22:35-38

16. Luke 24:33-34
1 Cor. 15:3-5

15. Matt. 26:69-75

1. John 1:42

Will Surrendered

A

Line A represents the level of life where the dominant characteristic is selfishness. It is the plane of carnal living, occupied by the unsaved, the carnal Christian, and the backslider.

Line B represents the level of mature, Spirit-filled Christian living. Redemption is that work of God whereby man is brought from the lower to the higher, into the place where his life is dominated by the love of God, by the glory and will of God, and by the well-being of others; all this as opposed to his old life where selfishness ruled.

Conscious committal of the will, and identification of one's purpose with the will of God, is usually established during the period of vision. It must be remembered that the subsequent valley period is NOT a time of backsliding or retrogression, even though many negative qualities come to light in a person during this time. Simon Peter remained consciously committed to Christ through the entire valley period of his life.